Object Lessons
Central Saint Martins Art and Design Archive

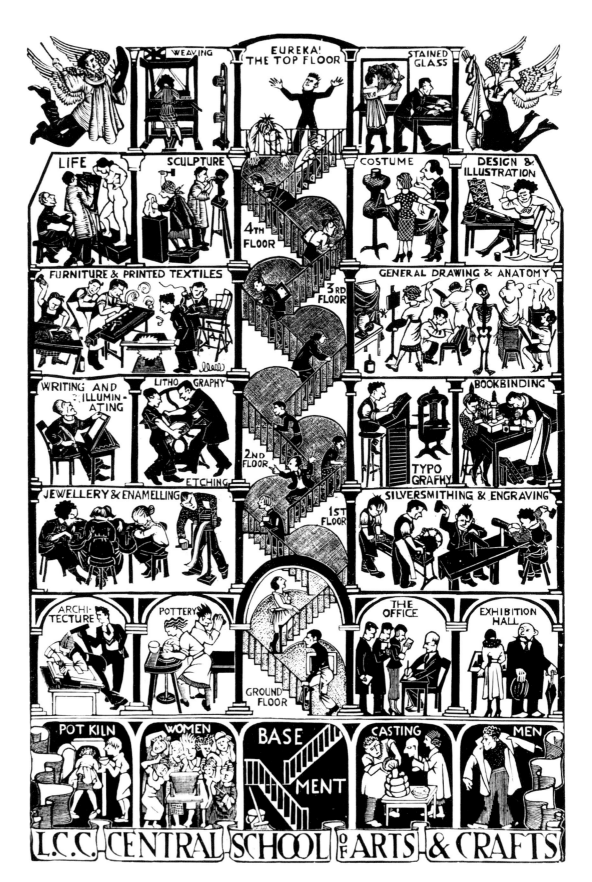

Object Lessons

Central Saint Martins Art and Design Archive

A Centenary Publication Edited by Sylvia Backemeyer

Lund Humphries Publishers, London

in association with The Lethaby Press
Central Saint Martins College of Art and Design, London

First published in Great Britain in 1996 by
Lund Humphries Publishers
Park House
1 Russell Gardens
London NW11 9NN

in association with
The Lethaby Press
Central Saint Martins College of Art and Design
London

Object Lessons
Central Saint Martins Art and Design Archive
Copyright © 1996 The London Institute,
Central Saint Martins College of Art and Design

British Library Cataloguing in Publication Data
A catalogue record for this book is available from the British Library
ISBN 0 85331 712 7

Distributed in the USA by
Antique Collectors' Club
Market Street Industrial Park
Wappingers Falls
NY 12590
USA

Designed by Alan Bartram (not cover design)
Made and printed in Great Britain by
BAS Printers Limited, Over Wallop, Hampshire
Typeset in Gill Sans

Frontispiece
Wood engraving by Heather (Herry) Perry, *c.*1929

Measurements in captions are given in centimetres, followed in
parentheses by imperial equivalents in inches.

Photographic Credits

The authors and publishers have made every effort to trace the
copyright holders or owners of works and photographs. If any
institutions or individuals have been incorrectly credited, or if
there are any omissions, we would be glad to be notified so that
the necessary corrections can be made in any reprint.

Fontworks p.22 (bottom right)
Luke Gertler p.32
Penny Hughes-Stanton p.59
Andrew Johnston pp.35, 36
Barbara Kane pp.59, 88
James Mosley p.22 (top)
Reading University Library p.45 (top), 58
Celia Rooke pp.43, 44, 57
Judith Russell p.13 (right)
Scottish College of Textiles, Galashiels p.71

Contents

Acknowledgements

I should like to thank all the contributors to this volume for the research they have undertaken on the archive, as well as for the essays published here. I would also like to thank the staff of Central Saint Martins Learning Resources Department, especially Vijay Dhir who was responsible for the photographs.

Sylvia Backemeyer

Foreword

The publication of this book of essays on the Central Saint Martins Archive marks the centenary of one of its founding colleges, the Central School of Arts and Crafts. Central Saint Martins College of Art and Design was formed in 1989 through the merger of the then Central School of Art and Design and Saint Martin's School of Art, which was founded earlier, in 1854. For more than 100 years, staff and students have made impressive contributions not only to art and design practice but also to education. The college is the largest of the London Institute art and design colleges and offers the most diverse and comprehensive range of disciplines in the country from foundation and undergraduate to postgraduate studies and research degrees – it is, in essence, the complete art college.

As we reach the millennium, the College continues to build upon the success of its past by pushing the boundaries of art and design education and practice. The College will shortly introduce a new innovative combined studies undergraduate degree course where architectural studies, a prominent discipline in Lethaby's time and very much reflected in the Archive, together with environment-related art and design, will play a major role. The course will combine disciplines across the full range, from fashion and textiles, graphic and product design including furniture, to jewellery, ceramics, theatre design and fine art. Central Saint Martins will continue to provide an unrivalled opportunity for students to select the best career pathway, enabling them to realise their potential and make a significant contribution to the new millennium. Accordingly, the College envisages that its graduates will play a key role in determining the quality of life for all, whether in a learning or working environment, enjoying leisure time or old age, or with disability.

Over the past thirty or so years, teaching collections have been historical curiosities, similar to the sculpture court at the Victoria and Albert Museum, as courses have eschewed models in the search for the avant garde. At Central Saint Martins, these collections have been seen as of great value in teaching, learning and research, as a source of inspiration and as a rich resource for exhibitions in the College's Lethaby Gallery. For example, a recent College exhibition of the Joyce Clissold archive, *Bold Impressions*, is now travelling to eight UK venues and is reaching a much wider public. The move towards a greater emphasis on independent learning adjusts the balance between learning resources and studio teaching as students define for themselves routes through their courses and develop their own special interests in preparation for professional lives. Learning strategies are a key part of this process and teaching collections and the Archive provide an invaluable basis. The groundwork has also been laid for using new technology, such as the Internet, to make this teaching resource more readily available.

An archive is a reflection of a rich and diverse tradition and a resource for research. But archives are also organic and developmental, added to and changed by changing circumstances. For example, the Central Lettering Record, a unique collection of letterforms built up over the past forty years and reflecting our distinguished tradition in typography and book production, has now been developed as a CD-ROM. This not only provides a link between 'old' and 'new' technology, but makes available a rich resource for teaching, for learning, for research and for the interested layperson. In defining the new, we also build upon the old which has a crucial role within the grammar of art and design, just as our letterpress unit has a vital role to play alongside computer-generated type.

The Collection is developmental in another respect; over the years the College has continued to add to the Archive. Additionally, in the five years since I have been Head of College at Central Saint Martins, the College has begun a long-term project of building up a substantial collection of current and past staff and student work, some of which is on permanent exhibition in the College, all of which will be of inestimable value for future generations of students and researchers. This resource relates to our exhibition policy which is increasingly taking on more of an international dimension; currently, work from the College Collection is being shown in Budapest. This policy complements the many links the College is building abroad through international courses such as our MA in Scenography, where students can choose to study at two of the four participating centres of London, Helsinki, Utrecht and Prague, as well as our franchise arrangements with Malaysia.

Much of the work around the research and organisation of the Archive, including the creation of a hypertext database and an object-based cataloguing system, has been possible because of funding from the Leverhulme Foundation and the Higher Education Funding Council for England. In particular I would like to express my gratitude to staff of Central Saint Martins, and also to the other contributors, all of whom are distinguished experts in their field, for the continuing work of this enterprise.

Professor Margaret Buck
Head of College
April 1996

Sylvia Backemeyer

The Teaching Examples Collection, Its Foundation and Development

Sylvia Backemeyer is Director of Learning Resources at Central Saint Martins. Her role includes the management and development of the Archive as well as mounting exhibitions and researching the history of the College. She edited *W. R. Lethaby, 1857-1931: Architecture, Design and Education* (Lund Humphries, 1984), with Teresa Gronberg, and curated the Lethaby exhibition with her. She also curated *Japanese Prints* and *In the Central Tradition*, and organised *Bold Impressions*.

Much has been written on the early history of the Central School and the pioneering sense of adventure which pervaded the Regent Street building. The craftsmen and designers Lethaby gathered round him have also become legendary. Less is known of the teaching collections which were started at that time. The purpose of this book is to remedy that, and this essay describes how the collection began.

The Special Collection of the Central School of Arts and Crafts originated in the Technical Education Board's Schools' Examples Collection. In 1894 W. R. Lethaby and George F. Frampton were appointed art inspectors to the Board. Part of their brief was 'the selection of casts and other objects given or lent to our Schools'.[1] Their report to the Board of 20 May 1895 stated 'it is our view that all examples should be good in themselves, of very various schools and classes of design and workmanship, and their purpose and material clearly stated . . . Besides the reproductions of really good and stimulating works of art by means of casts, photographs, coloured plates, etc, we would largely use real examples, such as pieces of wood carving, fragments of embroidery, fine pottery, book illustrations and binding, metal work, etc. In making a beginning we have necessarily bought things in the order in which we found them and you will not expect us to explain these purchases in detail. What may appear at first sight rough Gothic carvings, ugly Japanese prints and crude Dürer woodcuts, will we believe, prove of the greatest value by way of stimulus and suggestions as to methods.'[2]

The collection was originally stored in the Board's Central Art Department at the former Stationers' Hall in Bolt Court, off Fleet Street. It was indexed and fully labelled 'with every particular of material, methods, position etc'.[3] In 1896 it was moved to the original premises of the Central School of Arts and Crafts in Regent Street, and in 1906 to the new purpose-built building in Southampton Row.

In July 1896 the Technical Education Board gave £200 to the Art Inspectors to purchase art examples for the proposed Central School of Arts and Crafts, and the TEB minutes regularly indicate approval for sums of money for different purchases. It appears that Lethaby was personally responsible for most of the purchases, reporting back from time to time regarding his acquisitions and the gifts which had been received. Some of the items listed are still in the collection, others, such as those mentioned in the minutes for 29 July 1901, unfortunately are not. 'Mr Lethaby be authorised to spend a sum not exceeding £100 on the purchase of original cartoons by Sir Edward Burne-Jones'.[4] The collection still has a number of items with the Technical Education Board label but the vast majority that remain were added to the Central School Collection rather than to that of the Board. It therefore became a collection for use within the Central School itself rather than a circulating collection travelling to other schools. In his report *The Central School of Arts and Crafts, its aims and organisation*, in 1913, Lethaby's successor

F. V. Burridge specifically mentions the Art Examples Collection and its importance for the curriculum.[5] Although from the inception of the School a library is referred to in the prospectus and the book purchases were clearly housed there, it is also clear from numerous comments, particularly in the text and prefaces of the *Artistic Crafts* series of publications edited by Lethaby, that the examples were used in the studios. Early photographs show studios adorned with examples.

The Artistic Crafts Series of Technical Handbooks edited by Lethaby and published by John Hogg from 1903 were written by first-class craftsmen and women, most of whom taught at the Central School of Arts and Crafts. They covered all the main subjects taught at that time and enabled Lethaby and his staff to extend their teaching beyond the confines of the Central School. They are also a rich source of Lethaby's views on art education and illustrate clearly how he saw the 'Examples' collection being used. In the 'Editor's Preface' to F. M. Fletcher's *Wood-block Printing*, Lethaby wrote, 'Mr Fletcher is careful to insist that the colour prints shall not be a mere imitation of the Japanese. It is essential for the English artist to think of his methods in his own way, and while accepting the general principles of Japanese work, to modify and adapt them to the spirit of his natural art'.[6] Lethaby purchased a number of Japanese prints to use as teaching examples; many of them are still in the collection and are discussed in an essay in this book. In the TEB Minutes for 1895 Lethaby is quoted as saying 'I saw only today in a shop a collection of very cheap "old" Japanese colour printed books; these would be invaluable to the lithographers'.[7] In 1897 'Japanese and other books were purchased for the sum of 14s 4d' and in 1903, 'six Japanese colour blocks were bought for £5 10s 0d'.

Bottom left
Publicity for the *Artistic Crafts Series of Technical Handbooks*, edited by W. R. Lethaby, published by John Hogg

Bottom right
Albrecht Dürer, *The Knight, Death and the Devil*, wood engraving, 1513. 24.5 × 18.5 ($9\frac{3}{4} \times 7\frac{1}{4}$) (LCC Art example stamp). Archive P.64

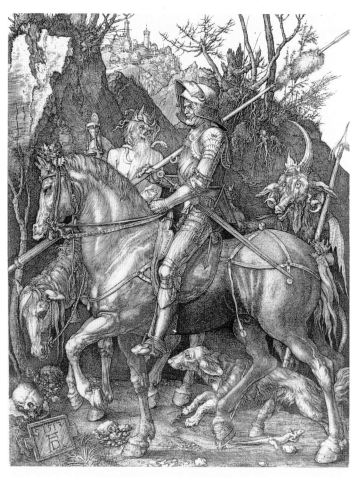

The Japanese prints were prominently exhibited in the entrance hall of the School. Two of the *Technical Handbooks* were produced as small folios of examples: *School Copies and Examples*, by Lethaby and Archibald H. Christie, 1904, and *Manuscript and Inscription Letters for Schools and Classes and for the use of Craftsmen*, by Johnston and Eric Gill, 1909. The 1904 folio included reproductions from Bewick and the *Flora Londinensis* together with illustrations of an English coat of arms, a sixteenth-century Italian alphabet, and a tapestry design.

As well as the separate 'special' collections which are the subjects of the essays in this book, there are numerous other smaller collections of material. The print collection is particularly rich; some are loose prints, others collected in portfolios. There are medieval woodcuts including some by Dürer from c.1511, lithographs by Daumier and Gavarni, c.1850; two portfolios of *L'Estampe Moderne* containing lithographs by Mucha, 1827, and Detmold's *Twenty-four Nature Pictures*, 1922. There is a watercolour of leaves by Ruskin which appears as an engraving in *Modern Painters*.

The extensive portfolio collection contains many standard works of the kind used for teaching design in the late nineteenth century, such as those by Owen Jones and Christopher Dresser, and numerous reproductions from galleries and museums. There are a number of unusual interesting items such as *Asian Carpet Designs* by Thomas Hendley, 1905, *Calico Printing in the East Indies in the Seventeenth and Eighteenth Centuries* by George R. Baker, 1920, and *Piranesi's Monumental Work First Published in Rome 1756*, edited by William Younger, 1900.

There are loose sheets from medieval books, pages from private presses, such as the

William Morris, *News from Nowhere* loosesheet, 1892, Kelmscott Press. 25×21 ($10 \times 8\frac{1}{4}$). Archive P.1231.7

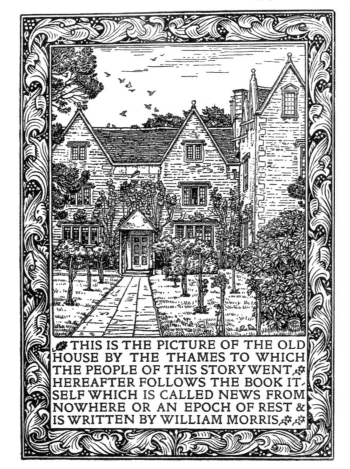

THIS IS THE PICTURE OF THE OLD HOUSE BY THE THAMES TO WHICH THE PEOPLE OF THIS STORY WENT HEREAFTER FOLLOWS THE BOOK IT SELF WHICH IS CALLED NEWS FROM NOWHERE OR AN EPOCH OF REST & IS WRITTEN BY WILLIAM MORRIS

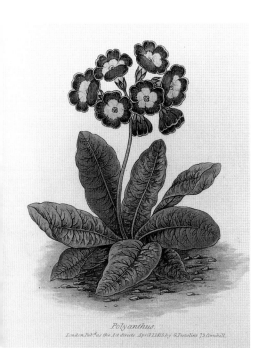

G. Testolini, *Rudiments of Drawing, Shadowing and Colouring Flowers in Watercolours, Contained in 36 Instructive Lessons*, 1818. Archive B.4177

Kelmscott Press, fragments of illuminations cut out of medieval manuscripts, and quantities of pages cut from books showing botanical illustrations, birds and animals, and fashion plates. It is not difficult to connect this material with the teaching carried out in the early days. Sometimes Lethaby helps us: 'I have had a present for the School, examples of the Kelmscott Press work (some loose sheets) through Mr Cockerell, one of Mr Morris's executors. These will be most valuable as examples of typography and ornamentation'.[8]

The book collection is extensive. It contains some handsome early printed books and incunabula, some on vellum, many beautifully bound. These almost certainly came into the collection at the time of Mason, Johnston and Cockerell to support the School of Book Production, as did the illustrated books and periodicals such as *Fleuron*, *Minotaur* and *Gazette du Bon Ton*. Lethaby's own special interests are extensively represented, especially architecture, one of the largest departments of the original School, and cartography; the collection has a fine example of a portolan chart on vellum dated 1570. Heraldry is a subject on which Lethaby was an authority. The heraldry books include St John Hope's *Stall Plates of the Knights of the Garter*, 1901, which would have been a valuable resource for Christopher Whall and his students in the School of Stained Glass. Silver and Metal Work, another of the major areas of the early Central School, is also well supported by the collection of books and portfolios. The natural history and botanical books are outstanding as one would expect from a school so strongly influenced by the Arts and Crafts movement. There are several herbals including Curtis's *Flora Londinensis*, Vols I and II, 1777, and Weinmann's *Over de Planten*, 1746. A rare volume on flower painting with a step-by-step guide is particularly delightful: *Rudiments of Drawing, Shadowing and Colouring Flowers in Watercolours, Contained in 36 Instructive Lessons*, published by Testolini in 1818. Bewick, as one would expect, is well represented. George Jack, who taught wood carving from 1908, wrote in the *Artistic Crafts Series*, 'in the absence of opportunity of study from life, no pictures or animals can compare in their usefulness to the carver to those by Bewick'.[9]

There are a number of oddments: printed ephemera, cigar-box labels and other examples of nineteenth- and twentieth-century packaging design; some samples of Morris and Company wallpapers; plaster casts of medallions; William De Morgan ceramic tiles; and some textile and embroidery samples including some nineteenth-century guard books. There are many early photographs and boxes of glass slides. Most of the latter have yet to be fully investigated, but some are known to have been used for teaching; T. J. Cobden-Sanderson used slides in his lectures on bookbinding. There is a fine collection of Japanese prints, some rare Japanese stencils, possibly used in textile design, and some Japanese woodblocks.

Over the years work by staff and students of the College has been added to the original teaching examples, sometimes through gifts but also by some modest purchases. The small collection of work by Lethaby has grown and we now have over eighty prints, drawings and watercolours, showing the range of his work in architecture and design.

There is also some student work in the collection including early sketchbooks and wood engravings which Dr Joanna Selborne discusses in her essay. There are lithographs and drawings by ex-students Alfred Bestal, Lynton Lamb and Pearl Binder, who went on to be book illustrators or graphic designers. The block by Heather (Herry) Perry, dated around 1929, of the interior of the Southampton Row building, is still regularly printed. Student work is represented in the printing and binding of books in the School of Book Production, and many named and unnamed designs for book endpapers are by students of Noel Rooke and John Farleigh. There are works by former teachers – Noel Rooke, Eric Gill, John Farleigh and A. S. Hartrick – and by post-war teachers including Gertrude

Hermes, Maurice Kestelman, Bernard Meninsky, Mervyn Peake, Blair Hughes-Stanton and Norman Ackroyd. Hartrick and Rooke both contributed to the Schools Pictures Scheme which was run by the LCC for a number of years, and the collection has some examples.

The rehabilitation and conservation of the Archive has been progressing since the Lethaby exhibition of 1984 when the College rediscovered these treasures. From 1990 to 1993 Leverhulme funding provided resources to organise the Archive and create a hypertext database of the non-book material. A successful bid to the Higher Education Funding Council for England (HEFCE) produced further funds to improve storage, undertake some conservation, and provide a part-time archivist for three years. Research funding from HEFCE has also made possible this book of essays and the study of different aspects of the archive. Hopefully this will stimulate further research and more gifts of material from staff and students of both founding colleges. Mary Schoeser's essay describes how this is already happening in textiles. The Sasakawa Foundation supported the conservation of the Japanese Prints. A grant from the HEFCE has allowed us to conserve some of the Lethaby material, much of the German Poster Collection, and the Joyce Clissold textile collection. This has been partly carried out by the Textile Conservation Centre at Hampton Court. Our connection with the Conservation Course at Camberwell College of Arts has enabled many objects to be conserved while providing their students with material for practising their skills.

Bottom left
Endpaper design by a student, c.1920s, blockprinted on paper. 41.4 × 27 (16¼ × 10½). Archive T.55

Bottom right
Gertrude Hermes, *The Yolk*, wood engraving, 1975. 35.7 × 30.5 (14 × 12¼)

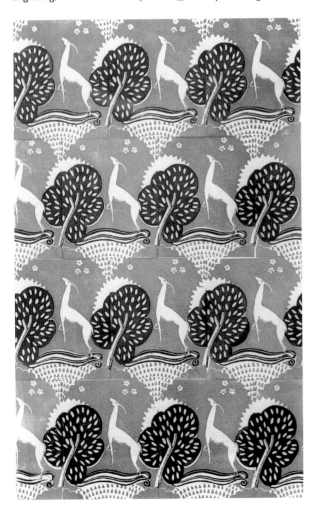

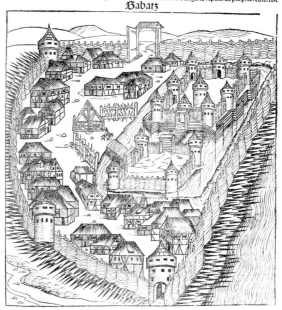

Page from *Nuremberg Chronicle*, typeset woodcut, 1495. 41.5 × 8.5 (16¼ × 11¼).
Archive P.45-1.33

In his writings Lethaby several times argues we need to study the legacy of the past by looking at examples in museums. He was clear that the aim was not to copy but to reinterpret the inspiration of the past. In the Teaching Examples Collection he created the Central School's own 'museum' so students could examine objects more freely than in the traditional museum. We cannot easily create that freedom today, but we hope that one day we will be able to allow students to use the collection again as its founder envisaged.

(Part of this essay was previously published in *The Journal of Design History*, Vol.5 No.4, 1992.)

1. *Technical Education Board Minutes*, November 1894.

2. *Technical Education Board Minutes*, May 1895.

3. *Technical Education Board Minutes*, January 1895.

4. *Technical Education Board Minutes*, July 1901.

5. *London County Council. The Central School of Arts and Crafts, its Aims and Organisation.* Report by the Principal, 1913.

6. F. M. O. Fletcher, *Woodblock Printing, Artistic Crafts Series*, John Hogg, 1916.

7. *Technical Education Board Minutes*, May 1895, May 1897 and 1903.

8. *Technical Education Board Minutes*, May 1897.

9. G. Jack, *Woodcarving: Design and Workmanship. Artistic Crafts Series*, John Hogg, 1903.

Stuart Evans

Teaching Collections, Then and Now

Designer and design historian Stuart Evans works at Central Saint Martins specialising in research studies and organising conferences. He broadcasts on design for television and radio, most recently on car styling. Among his publications are studies in research, architecture, furniture and *Pyrex: Sixty Years of Design*, with regular contributions on the Arts and Crafts movement.

In a very real sense, the teaching collections of a college of art and design form its tangible history. In museum or auction house an art work is the object of connoisseurly appreciation, but in a teaching collection it witnesses to the values and aspirations of the college and to the history of its curriculum and pedagogy. This is true of Central Saint Martins with a century as a leader and innovator in education in art and design.

This essay considers the intentions behind the collections, their application, and the subjects taught. It looks at the early days of the Central School of Arts and Crafts, discusses later developments and concludes with their recent and future use, concentrating on the Central School collection since little has survived from St Martin's School of Art. We cannot directly re-experience how these teaching examples were applied in studios and workshops, but we can speculate about their use through secondary materials such as the prospectuses listing the college's aims, staff and courses, the polemical-practical books on handicrafts written by the Arts and Crafts heroes who taught here, the samples of students' work, and the art works themselves which continue to seduce and generate a desire to look, handle and emulate.

When the Central School was established in 1896 it was based firmly on principles drawn from the Arts and Crafts movement and was thus radically different from what was available elsewhere in London.[1] Indeed the Collection of Teaching Examples is distinctively Arts and Crafts in its role and intentions. The prevailing educational scheme, 'the South Kensington system',[2] was not vocationally oriented. This prioritised drawing skills and taught how to ornament. Teaching examples were either facsimiles of historical pieces or ornament produced for copying with neither medium nor purpose considered; nor was the vitality of the craftworker's touch apparent. Lavish publications like Owen Jones's *Grammar of Ornament* were used, and while he encouraged students to work from nature in developing ornament, the emphasis was on flat pattern.

The art works acquired for Central School were chosen on a very different basis. They were characterised by vitality and directness, showing the energy and expressiveness of the craftworker, and the influence of medium, production processes and 'function' in their design. They showed enrichment developed from structure and symbolic value relating to purpose or location.

The Arts and Crafts movement reshaped art and design education in the 1890s, and has continued to exert a powerful influence. The shift was towards a method in which students were encouraged to develop studio and workshop skills, and it promoted the idea of 'learning by doing' which remained central to art and design education in this country for the next seventy-five years, and still influences it today.

Its impact derived ultimately from John Ruskin, and in particular his text on art and

labour, *The Nature of Gothic*.[3] This influenced William Morris who, when he started the Kelmscott Press, published an edition in 1892, noting in an introduction that it was 'one of the very few necessary and inevitable utterances of the century', which 'seemed to point out a new road on which the world should travel'. The collection includes a copy bound in the School – a cheap edition for circulation among the artisans whose interests it addressed – but finished in tan calf and tooled in gold. In Ruskinian terms the generosity of the binding represents the craftworker's celebration of the text. In a romantic sense this suggests an ideal of mutuality in a medieval stonemason's lodge.

The pervasiveness of Ruskinian influence at the Central School of Arts and Crafts extends even to its name. It is also apparent in the structuring of the curriculum around architecture, reflecting the interdependence of the crafts. The first prospectus addressed itself to four categories of students, starting with 'those engaged in different departments of building work – architects, builders, modellers and carvers, decorators, metal workers, etc', then to 'designers in wallpapers, textiles, furniture'; next to 'workers in stained glass, bronze, lead, etc', and lastly to 'enamellers, jewellers and gold and silver workers'. It lists first the classes in architecture with the other 'supporting arts' following on. Instead of being arranged by trades, it is grouped on a model rather literally based on architecture, the fabric of the building first designed, then built and enriched, followed by its furnishing and successive stages of adornment. Architecture becomes a metaphor embracing the distinctions of creative responsibility in the crafts, and their application to reveal the building's status, covering qualities of materials and standards of workmanship as well as iconology.

The Central School was *the* new college of the 1890s, although not the only one influenced by the Arts and Crafts movement. What made the Central School different was its concentration upon providing a practical-based training in the crafts for workers in local craft industries. The Central School's egalitarianism shows in the early prospectuses. Its courses were all part-time, intended 'to provide instruction in those branches of design and manipulation which directly bear on the more artistic trades'. They were only open 'to those actually engaged in these trades', with 'no provision for the amateur student of drawing or painting'. Its students included mature workmen as well as apprentices, learners and improvers, with graduated fees depending on income, classes being free to those who earned little. There is no mention of separate classes for different levels of skill – so all must have learned together – nor of certificated examinations. It advertised LCC Technical Education Board Art Scholarships and Exhibitions, and listed prizes for museum or art gallery studies. From 1899 there were classes in Modelling and Drawing from the Life, separately for men and women. To counteract the division of labour experienced in trade workshops, students were introduced to the breadth of the craft, the specialist materials and processes and building production skills, designing what they made. A Drawing and Design class, complementary to the workshops, included 'work suited to the individual needs of each student, having regard to the craft at which he works'. Pieces from the Teaching Collection were featured and views of the studios show a sculpted Gothic spandrel panel placed high on the wall while smaller items are in showcases so that decoration and finish can be inspected.

We can speculate about how the teaching examples were used. Some would have been to show the effects of different materials and different processes of making, some as examples of finished artefacts, and others to demonstrate practical requirements of finish, scale, position or purpose, or to be used as handling samples to familiarise students with their tactile and visual qualities. It seems clear that rather than copying from the collection, students were to see them as exemplars to be emulated. The

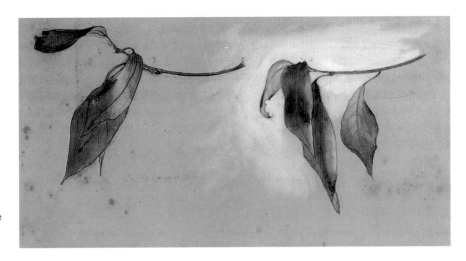

John Ruskin, *Leaves*, thought to be engraved for *Modern Painters*, Vol.IV, plate 43, pencil and watercolour, 1843. 15.7 × 30 (6¼ × 12). Archive F.47

collections also reveal the role that tradition played. No formal history or theory of art or craft or architecture was taught, although there was much contemporary publishing in these fields and many texts from the period remain in the School's collection. Instead, the students were to see themselves as part of a tradition which reached back into history. Invention for its own sake was less desirable than respect for tradition and a sense of continuity. It is as if Lethaby wished to re-establish the idea of style as a living tradition.

The early prospectuses list courses covering the crafts that served West End luxury trades: silverware and jewellery from Hatton Garden, furnishings, including textiles and embroidery, in Oxford Street and Tottenham Court Road. The collection includes samples of Morris and Company wallpapers. Soon were added the crafts which made up book production, repair and conservation, reflecting the publishing houses and antiquarian booksellers in Bloomsbury. All these were craft industries, involving hand manufacture rather than industrial production. Other luxury trades were not represented because they were taught elsewhere. There was no coachbuilding, for example, although Long Acre, centre of the carriage trade, was near by. Nor did it include graphic design for advertising, display skills for shop windows or design for mass production in factories. These came later.

In its first decade new courses were offered each year. This rapid expansion suggests the excitement and intensity of the new School. In 1902 the curriculum was reorganised with courses grouped under Building Work, Work in Precious Metals, and the Crafts of Book Production. Expansion was continued, although without the previous tight focus. A new area of teaching, a course in Dressmaking and Costume Design, was started in 1905. There were proposals, subject to demand, for classes in Typography, Building Construction, Tempera Painting, Mosaics, Ivory Carving, Pottery Painting, Tapestry and Weaving, Gesso Work, Modelling for Plasterers, Ornamental Plastering, Metalwork for Cabinetmakers, Work in Wrought Iron and Brass, and Metal Casting. The following year courses in Painting on China, Carpet and Linoleum Design and Design for Monumental Masons were added. Daytime courses were started and specialist classes for young apprentices in the precious metals and book production trades. A further reorganisation of the curriculum occurred in 1908 when the School moved to the smart new building in Southampton Row which Central Saint Martins still occupies.[4] This was purpose-built, designed by the LCC Chief Architect W. E. Riley in response to Lethaby's brief. The courses were regrouped into seven schools, one to each floor, which were listed in order of ascent in the 1908 prospectus, as shown in the frontispiece:

3

The Central School of Arts and Crafts.

PROSPECTUS.

This School, opened on Monday, 2nd November, 1896, has been established by the Technical Education Board of the London County Council, to provide instruction in those branches of design and manipulation which directly bear on the more artistic trades. Admission to the school is, within certain limits, only extended to those actually engaged in these trades, and the School makes no provision for the amateur student of drawing and painting.

The special object of the School is to encourage the industrial application of decorative design, and it is intended that every opportunity should be given to the students to study this in relation to their own particular craft.

There is no intention that the School should supplant apprenticeship —it is rather intended that it should supplement it by enabling its students to learn design and those branches of their craft which, owing to the sub-division of processes of production, they are unable to learn in the workshop.

The instruction is adapted to the needs of those engaged in the different departments of Building Work (Architects, Builders, Modellers and Carvers, Decorators, Metal Workers, &c,), Designers in Wall Papers, Textiles, Furniture, Workers in Stained Glass, Bronze, Lead, &c., Enamellers, Jewellers and Gold and Silver Workers. Other departments will be opened in response to any reasonable demand.

The following classes are now open :—

I. ARCHITECTURAL DESIGN.—The Studio is open to students during school hours for study and practice. Mr. RICARDO is present on MONDAY and THURSDAY EVENINGS from 7 to 9.30.

The subject is treated—by lecture and otherwise as circumstances may determine—from the point of view that architecture should respond to the facts of modern life. Concurrently with instruction in design in architecture will be given demonstrations of the mechanics of construction.

Drawing (mostly non-geometrical) will be taught, and all students will be expected to devote some time to gaining proficiency in this direction. Studies from natural forms will be made a basis for the consideration of ornament.

Classes for practical work in Masonry and Leadwork are held, and students of architecture are especially recommended to join them, and also to work at modelling.

Central School of Arts and Crafts
Prospectus, 1896. Archive B.4782

Architecture and the Building Crafts; Silversmith's Work and Allied Crafts; Book Production; Cabinet Work and Furniture; Drawing, Design and Modelling; Needlework; Stained Glass Work; and Mosaic and Decorative Painting (including Tempera).

The School's curriculum was consolidated and continued with only small changes until Lethaby resigned in 1911. Thereafter came a progressive change away from the original Arts and Crafts ideals. His successor published a reappraisal, which included renaming it 'The Central School of Artistic Crafts' (which did not happen), as a national institution 'to further the highest development of the artistic handicrafts' and 'afford an education in and by means of the artistic craft',[5] which was substantially achieved. The previous tight focus on training men and women engaged in local craft industries became broader. It meant different links with other LCC schools, henceforth to act as feeders, and with the trade bodies in precious metals and book production for which the School provided 'practical trades classes', open only to those trades. Although the main changes did not take place until after the Great War, a shift was apparent from 1912 in the arrival of the new discipline of 'scientific management' in the syllabuses with lectures on The Science of Salesmanship, The Science of Negotiating, and The Scientific Selection of Colours, in a course of Lectures to Furniture Salesmen. Similar series followed for Retail Jewellers, the Textile Distributive Trades and Book Production. A far cry from Ruskin! Commercial art subjects were added, including display techniques and lettering for advertising. There were University Extension Course lectures, and courses in the history of art and of architecture. The School hosted an LCC exhibition of Pictures for Schools, to be used in the classroom to assist learning by providing attractive and informative illustrations,[6] and a series of lectures and visits on Art and the Community, covering town planning, house design and the design of furnishings and utensils, started in 1919 at the same time as the *Daily Mail* Ideal Home Exhibition. This typified the 'Fitness for Purpose' design rationalism pioneered by the Design and Industries Association (DIA), founded in 1915 in response to the German Deutsche Werkbund. It accorded with the School's new stance. Among its staff were DIA members.

The main change was the introduction of courses in the crafts aimed at full-time students rather than artisan craftworkers. These lasted four years; and a diploma of craftsmanship, assessed by examination, was introduced. New subjects included Heraldic Design, Pottery and Theatrical Design; the last two continue today. These arrangements remained throughout the 1920s and into the 1930s, with some three-year full-time courses, including Textiles Design and Printing and Publicity, for students who wished to work in industry. These represent another development – education for designers to work in industry, rather than as craftworkers. In 1938 an experimental course in Industrial Design was added, named Design for Light Industry. This innovative course aimed to train its students, 'sculptors, painters, architects and others', to design 'articles of everyday use' through 'a co-ordinated training in technique and form'. Its radically different approach emphasised abstract composition rather than crafts mastery. The historian and apologist of modernism Nikolaus Pevsner commented:

'The most interesting establishment, as far as the problems of contemporary design go, is unquestionably the London Central School of Arts and Crafts. Its derivation from the Morris Movement is still clearly recognisable. From its beginnings, it has taken care to develop its workshops, and some of them, which have found support from local industries, have in fact succeeded in obtaining fully adequate equipment. In other classes the outlook is still pure craft. The school as a whole appears full of vitality and keenly interested in present-day trends.'[7]

With the rise of modernism as the basis for art and design education, the use of

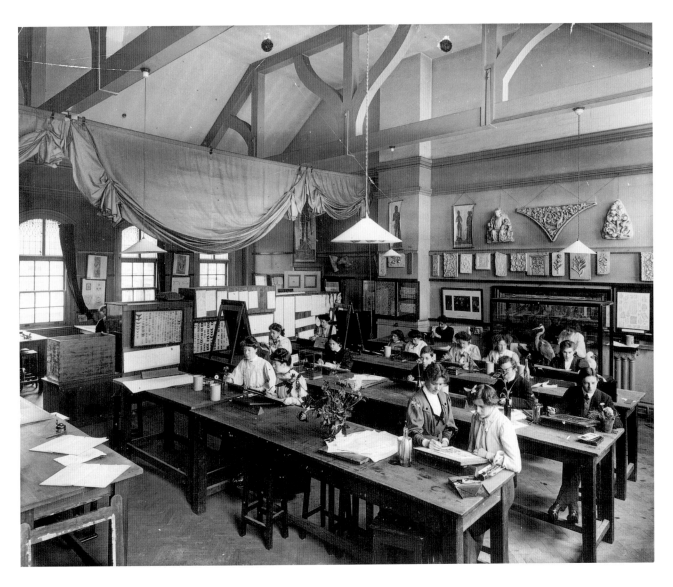

Contemporary photograph showing teaching examples in a studio setting, c.1905

teaching examples diminished, although they continued relevant while the School's programme remained craft-focused. Acquisitions linked to traditions shifted to those which reflected contemporary life and practice. The 1920s German film posters are an obvious example: what could be more typically twentieth-century in subject, colouring, shapes and letterforms? The examples of staff and student work in printmaking start at this time, continuing the emphasis on craft skills lost in other areas.

The shift to a more cerebral approach to design teaching seems to have moved in step with the increasing flood of illustrated books and periodicals reporting developments in art, architecture and design in Europe and North America. The publications sponsored by the DIA[8] and a new type of design-focused exhibition were a UK contribution which gave access to a wider and more cosmopolitan resource of contemporary material. The collection contains an excellent holding of this.

After World War Two the emphasis of the Central School's teaching changed again, from part-time vocational courses for particular trades, when the National Diploma in Design (NDD) scheme was introduced, and then in the mid-1960s when the School was recognised as a centre for the Diploma in Art and Design (DipAD) and the Higher

1. Backemeyer and Gronberg (eds), *W. R. Lethaby (1857-1931): Architecture, Design and Education*, 1984. Godfrey Rubens, *W. R. Lethaby: His Life and Work (1857-1931)*, Architectural Press, 1986.

2. Rubens, op.cit. Outlines Lethaby's impact on the 'South Kensington system'.

3. 'The Nature of Gothic' originally formed a chapter in *The Stones of Venice*, 3 Vols, 1851-4, and has been variously reprinted as a freestanding text.

4. A history of the planning and arrangement of school buildings in relation to the teaching, including Central School, is given in David Jeremiah, 'The Culture and Style of British Art School Buildings: Part One, The Victorian and Edwardian Legacy', *Point: Art and Design Research Journal*, 1995, 1, pp.34-47.

5. London County Council, 'The Central School of Arts and Crafts, Its Aims and Organisation: A Report by the Principal [F. V. Burridge]', 1913. (This was set, printed and bound at the Central School of Arts and Crafts.)

6. London County Council, *Interim Report of the Special Advisory Committee on School Pictures*, 1920. (This was set, printed and bound at the Central School of Arts and Crafts.)

7. Nikolaus Pevsner, *Academies of Art, Past and Present*, Cambridge University Press, 1940, p.289.

8. The sequence of publications from the DIA reflects the progressive shift towards modernism across the 1920s and 1930s; these are described in Nikolaus Pevsner, 'Patient Progress III: The DIA', *Studies in Art, Architecture and Design*, Vol.2, *Victorian and After*, 1972 (originally published in the DIA Yearbook, 1964-5).

9. The post-war development of art and design education in Britain can be seen in: David Warren Piper (ed.), *Readings in Art and Design Education: 1, After Hornsey*, and *2, After Coldstream*, Davis Poynter Limited, 1973.

10. The exhibitions are: *In the Central Tradition: Artists' Books*, 1985, which made the connection between the School of Book Production and Artist Book Makers from the Central; *Japanese Prints*, 1993 (the Sasakawa Foundation giving money to conserve the prints); and *Bold Impressions: Block Printed Textiles*, 1995, which focused on the Joyce Clissold collections, contextualising it within national developments in the field. This exhibition is touring to eight venues from October 1995-May 1997. The catalogue, of the same name, by Mary Schoeser, is published by Central Saint Martins College of Art and Design, The London Institute.

Diploma in Design (HDipDes).[9] This national system of higher education in art and design owed something to the Bauhaus, with a similar structure of levels: Foundation-Diploma-Higher Diploma, and an emphasis upon teaching by project.

Although subject division by craft medium survived, the DipAD scheme presupposed an aggressively modernist stance. This, along with an increase in student numbers and an expansion of studio and workshop resources, led to a widespread reappraisal of accommodation and teaching material which impacted on teaching collections up and down the country. Many were dispersed at this time as being no longer of use, space-consuming, and worse, indicators of the 'old thinking', then cast overboard. A development against this trend was the inception of the Central Lettering Record which was based on an idea similar to the original Teaching Examples Collection. It brought together craft material from different cultural and historical sources and was intended to promote original work in the studio. In the mid-1970s History of Design became a subject alongside the design disciplines, rather than a part of art history, so there was a regrowth of interest in teaching collections as part of the history of education and for study in their own right.

Like the iceberg, the mass of work already undertaken in the Special Collections is not at once apparent. The tasks of cataloguing and conservation, the creation of an improved physical environment to contain the Archive, and facilities for study, are only appreciated by those directly involved. Other developments are more visible, such as the series of exhibitions and related publications culminating in this book.[10] These essays offer an overview of the main areas of the Special Collection and show the potential for further research. They are currently being used in several ways, including academic study, with an emphasis on research skills, the development of connoisseurly values for use in design and design-related areas; and for practice-based and practice-led design applications. A central role will continue to be academic study with projects focusing upon some area or aspect of the collections or upon the context of its assembly or usage.

The development of connoisseurly values links back to the original role of the teaching examples. Students can use samples to explore the materials, processes and enrichments used to help develop sensitivity to intrinsic qualities of surface, texture, colour and form, and the less tangible ones of symbolism, iconography and resonance. These skills are of increasing importance in saturated world markets where the merely competent product is no longer sufficient.

The Archive should continue to acquire artefacts as exemplars, items patinated by use or brand-new ones, and examples of designs for products, perhaps by members of the College, with supporting interviews and samples. Finally, there is the growth of practice-based applications in design. An excellent example is the Central Lettering Record research described in Eric Kindel's essay. It is being developed on CD-ROM to make the letterforms and typeforms more widely accessible.

In its century of progress Central Saint Martins has moved through several phases embracing a succession of educational theories, but has maintained an emphasis on studio-based 'learning by doing', and on links with the practice of art and design outside the College. Interestingly, in its centennial year, a new course is being launched which not only continues these emphases but reintroduces the architectural focus which was the impulse behind Lethaby's original plans. This new cross-disciplinary honours degree in Industrial and Environmental Design is very different from what was taught a century ago, but then Lethaby used tradition as a starting point rather than as a point of arrival. The Special Collection, too, is not static nor simply consolidating its holdings, but is continuing a development based on its traditions.

Eric Kindel

The Central Lettering Record

Eric Kindel is currently the Research
Fellow for the Central Lettering Record's
interactive multimedia research project,
serving as its editor and designer. He is
also course tutor on the MA
Communication Design course at Central
Saint Martins in addition to carrying on his
own consultancy work.

The Central Lettering Record is undoubtedly an Archive far broader than its name
suggests. Though begun with a lettering bias, the Record has extended its collecting well
beyond the history and formal evolution of lettering it first announced as its frontier.
After more than thirty years of collecting it now includes a typographic scope nearly as
wide as that representing lettering. But the name of the Archive and its early intentions
reveal a state of affairs in art and design training at the Archive's inception that still echo
in the activities of the Central Lettering Record today.

The early years of this century were marked by a revival in lettering and calligraphy
inspired by Edward Johnston's pioneering classes at the Central School of Arts and
Crafts. Johnston, together with Graily Hewitt, created a generation of students and
teachers convinced of lettering's important role in the education of graphic designers.
Yet by the 1950s and early 1960s the balance of teaching had begun to shift decidedly
toward the Continent's modern movement in typography. The modern movement's
post-war proponents at the Central – Jesse Collins, Anthony Froshaug, Nigel
Henderson, Herbert Spencer and Edward Wright – were a strong influence on the
training of a new generation of professional graphic designers.[1] Not surprisingly, others,
for whom lettering and calligraphy remained an equally relevant foundation for teaching,
harboured concerns that in the trend towards typographic dominance in the art
schools, lettering and its traditions would be dissipated and forgotten.

Yet articulate voices at the time recognised, too, the diversion toward sterility that
the movement fostered by Johnston had developed in practice. Nicolete Gray, in her
1960 book *Lettering on Buildings*, identified a limited conception of the tools of lettering
and a failure to experiment in new media as largely responsible.[2] As Gray later observed,
'. . . the failure of the Johnston tradition to react to changes and developments in the
other arts . . .' was to blame for the abandonment of lettering and calligraphy training in
the art schools.[3] 'In the interval since Johnston's retirement in the early Thirties there
has been a revolution in art in England: we have rejoined the mainstream of the modern
movement . . . Behind the evolution of the modern movement has been a great
rethinking of the bases of aesthetic terms, a process which has involved the fundamental
reorientation of student training, a job which is still being worked out; no wonder that
Johnston's methods are completely out of touch. They could hardly be otherwise.'[4]

In 1963 the Central School first took steps to counter the decline in lettering
instruction and reinvest it with the vitality Gray felt it so badly lacked. Nicholas
Biddulph, then teaching on the course in Graphic Design, began seeking material to
support his own instruction in letterforms. But he found very few images for study, and,
in particular, photographs of the ancient Roman achievements seemed largely
unavailable. Biddulph was able to acquire a set of images of the Roman inscriptions

recently taken by the printing historian James Mosley and these became the first entries to the new Central Lettering Record. For the next two years the collection grew slowly until, in early 1965, Nicolete Gray was invited to outline and launch with Biddulph a course in lettering. The nascent collection provided a ready supply of reference material and with Gray's arrival, and the needs of the new course, the Record itself underwent an acceleration in its collecting activities.

To create a significant Archive of study material was the vision of Biddulph. But it was Gray who gave voice to the aims of the Central Lettering Record by articulating the concerns of lettering instruction that both she and Biddulph shared. Crucially, the Archive would provide in one location a full and representative overview of lettering.

Central Lettering Record. Detail of the Forum, Rome, AD2 (Reproduced courtesy of James Mosley)

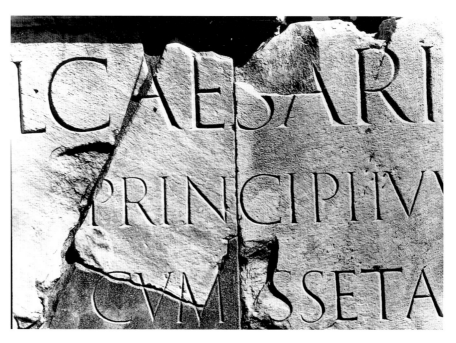

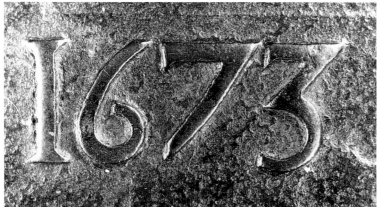

Central Lettering Record. Cast iron floorgrave, 1673. Wadhurst Church, Sussex

Right
Cornel Windin, FF Magda typeface, 1993 (with permission of Font Works UK)

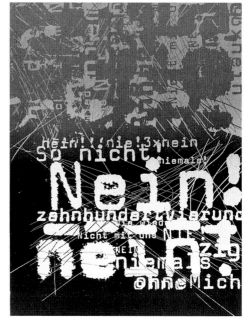

Sources would range from Pompeiian rustic sign-writing to Anglo-Irish manuscripts and medieval court hands to twentieth-century expressionist calligraphy. The inspiring breadth of lettering's creative possibilities would demonstrate its relevance not only to the historian but in the designer's daily activities.

The areas Biddulph and Gray covered in their intensive eleven-day course were also guided by Gray's concerns. Fundamental to their teaching was an exploration of form, whether the 'Essential Forms' or 'bare body' of letters sought by Johnston and Eric Gill or the expressive forms of Imre Reiner, Ben Shahn, Art Nouveau or the concrete poets. From these examples and the tradition that stretched back to the ancient Romans, a larger view of the letter's formal qualities would evolve. It allowed the rich but at times seemingly anachronistic history of letterforms to be brought into the present. 'In order to reuse a . . . letter we have to first see it as line or outline, as shape and movement, and forget its origin. The training of a generation of abstract art has I think given us now this power, and so made psychologically available the whole range of historic letterforms.'[5] Gray emphasised the vitality of lettering inherent in many media, warning, as she had done earlier, of the pitfalls that awaited those who refused to look beyond the chisel. Though Gray stopped short of embracing the new typographic trends, she did envision lettering and calligraphy challenging the typographer's dependence on predetermined letterforms, offering instead an exploration of the abstract and spontaneous.

The Record expanded rapidly to accommodate the course's widening needs and its scope soon reflected not only Western lettering but that of other cultures such as China and Islam. Typography and its development of the letterform in print also became well represented. Biddulph collected with considerable energy, always maintaining the high standard of photography set by Mosley's Roman images. Biddulph devised techniques of on-site macro photography and produced images exceptionally rich in tone, conveying a raw physicality in the inscriptions, writing, printing and punch cutting illustrated. Both he and Gray recorded enthusiastically in Britain, on trips abroad, and at the British Museum, the Bodleian Library, the St Brides Printing Library and the Bibliothèque Nationale. They were also fascinated by architectural and environmental lettering and recorded fine examples of lettering in danger of demolition.

Photography was clearly the most appropriate medium for collecting. All important objects could be represented regardless of size, location, expense of the artefact, or conservation. Slides illustrated the course lectures, and prints, protected in plastic, accommodated close examination. Enlargements allowed the epic sense of inscriptional examples to be sensed and conveyed qualities of the materials and tools employed. Photography also led to Biddulph's invention of the 'Letterform Series' setting out extensive profiles of letters and types for comparative analysis.

Throughout the 1960s and 1970s, the Central Lettering Record provided for the teaching, research and publication demands placed upon it. The Record itself was recognised as a reseach project by the Inner London Education Authority, enabling one of the first research appointments to be made in an art school. At this time Gray published *Lettering as Drawing*, detailing her vision of lettering's tradition and elaborating upon ideas she had encouraged in the lettering course. The Record provided for several exhibitions that toured Britain and countries abroad, fulfilling another of the founders' aims: that the Archive disseminate the richness of lettering to an audience beyond the Central. Through these activities the Record was brought to the attention of many organisations who provided either direct sponsorship or articulate expert support. And the Record was supported by a group of well-regarded practitioners, educationalists and curators including Misha Black, John Dreyfus, Alfred Fairbank, John Pope-Hennessey, Nikolaus Pevsner, Herbert Spencer, Reynolds Stone, Walter Tracy and Edward Wright.

In the late 1970s Nicolete Gray retired from teaching although she continued to write, publish and contribute to the Record. Biddulph remained teaching the course in lettering that he and Gray had established and the Record served this course as its primary function. However, work on the Record languished in other respects with the termination of the research assistant's position and diminishing levels of funding. And the merger in 1989 of the Central School and Saint Martin's School of Art seemed to speed the slowly declining influence of lettering on teaching. The decidedly typographic orientation of the Saint Martin's course in Graphic Design minimised the importance instruction in lettering played in the consolidated curriculum. Biddulph's own retirement in 1991 left many questions clouding the Record's future role at the new Central Saint Martins.

Following Biddulph's retirement, no movement to reactivate the Record seemed imminent and its possibilities remained largely unrealised. It was not until late 1993, when the Higher Education Funding Council for England sought research proposals in art and design, that the role of the Record could be reconsidered. The College recognised an opportunity to blend with the Record its own expertise in type design, typography and interactive interface design. The proposed research would be directed not only toward making the Record accessible through interactive digital media, but ensuring that its accessibility would support research into new teaching products and learning practices so important to the founder's original intentions. The research would also document the explosion of letterform creativity sparked by the personal computer, adding artefacts of contemporary typography to the existing Record. The scope of the Archive was set to grow and the dissemination of its wealth was once again possible.

The funding that the Central Lettering Record proposal eventually received represented a significant change in the fortunes of the Archive. It could now support an eight-member team working in areas of cataloguing, classification, database construction and interface design. But the team's work also represented a move away from creative lettering as the Record first emphasised. Though the assembly of a database for the Archive was to be comprehensive, substantial energy would be directed toward the Record's typographic contents. For the research team, this was the area of greatest interest and contemporary relevance. It seemed a capitulation to the typographic hegemony that had always threatened and for which the Record was to be a counterweight.

Yet such a view is misleading. That the expertise of the research team is largely typographic is partly a legacy of curriculum changes forty years previously. Although typography has assumed a key position in the current research, what remains of greater importance is the Central Lettering Record's ability to sustain new ideas for teaching and learning. Beyond the research specifics, such intentions as set out by Gray and Biddulph are still paramount. If the Record is to remain relevant, it must perform those activities that transcend trends in teaching content and that perpetually reconfigure its uses for new educational climates and design practices. To prove itself as an invaluable resource, in spite of trends, is the Central Lettering Record's strongest defence, not from typography, but from neglect and disregard.

In conclusion, the digital typography of recent years and its fluid electronic expression may be seen as yet another reassessment of letterforms Nicolete Gray thought imperative if the tradition of lettering were to remain vital. That this work is of importance to the current research and falls under the title of typography may represent the closing of an intractable circle that for so long kept apart two often irreconcilable traditions.

1. Robin Kinross, 'Letters in the City', *Eye Magazine*, 1993, No.10, Vol.3, pp.68-9.

2. Nicolete Gray, *Lettering on Buildings*, Architectural Press, 1960, p.19.

3. Nicolete Gray, *Lettering as Drawing*, Oxford University Press, 1971, p.3.

4. ibid., p.1.

5. ibid., p.169.

Pompeiian ornament from *Cundall's*
Examples of Ornament, London, 1855.
40 × 20 (15¾ × 8)

Saint Benedictus, *Regula sanctissi nostri patris Benedicti*, illuminated manuscript on vellum, c.1500. 29 × 15 (11½ × 6). Archive B.417

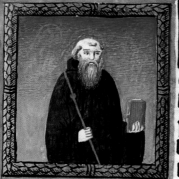

In nomine dni nostri iesu xpi: incipit prologus regule sanctissimi patris nostri benedicti abbatis.

Ausculta o fili precepta magistri: et inclina aurem cordis tui et admonitione pij patris libenter excipe: et efficaciter comple: ut ad eum per obedientie laborem redeas: a quo per inobedientie desidiam recesseras. Ad te ergo nunc meus sermo dirigitur: quisquis abrenucians proprijs uoluntatibus dño xpisto uero regi militaturus obedientie fortissima atqz preclara arma assumis. In primis ut quicquid agendum inchoas bonum: ab eo perfici instantissima oratione deposcas. Vt qui nos iam in filiorum dignatus est numero computare: non debeat aliquando de malis actibus nostris contristari. Ita eni ei omni tempore de bonis suis in nobis parendum est: ut non solum ut iratus pater suos non aliquando filios exheredet: sed nec ut metuendus dominus iritat malis nostris ut nequissimos seruos perpetuam tradat ad penam: qui eum noluerit sequi ad gloriam. Resurgamus ergo tandem aliquando: diuino excitante nos scriptura ac dicente. Hora est iam nos de somno surgere. Et apertis oculis nostris ad deificum lumen attonitis auribus

Noel Rooke, *Angel*, after a detail of a
Flemish tapestry at the South Kensington
Museum, watercolour, 1899. 28 × 22
(11 × 8¾). Archive F.46

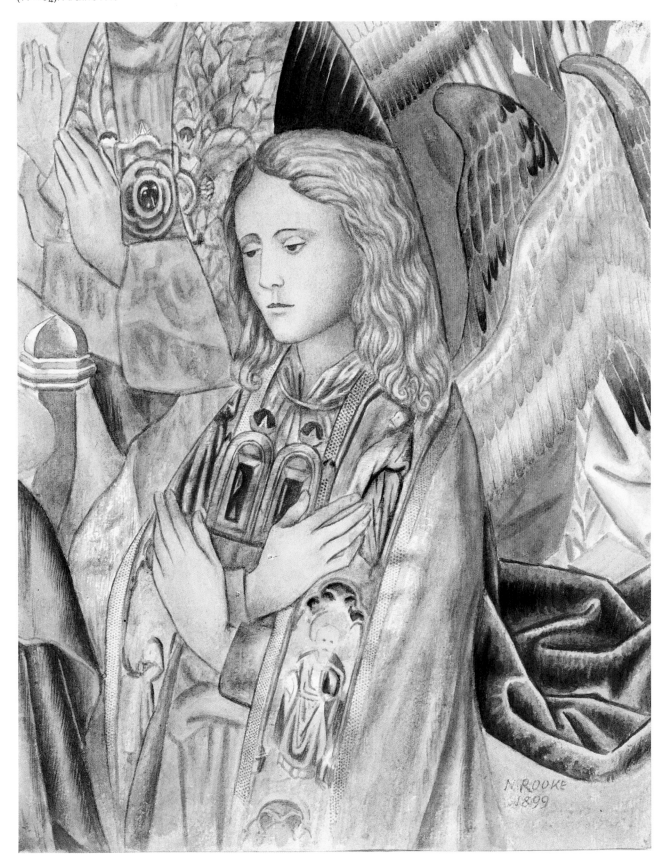

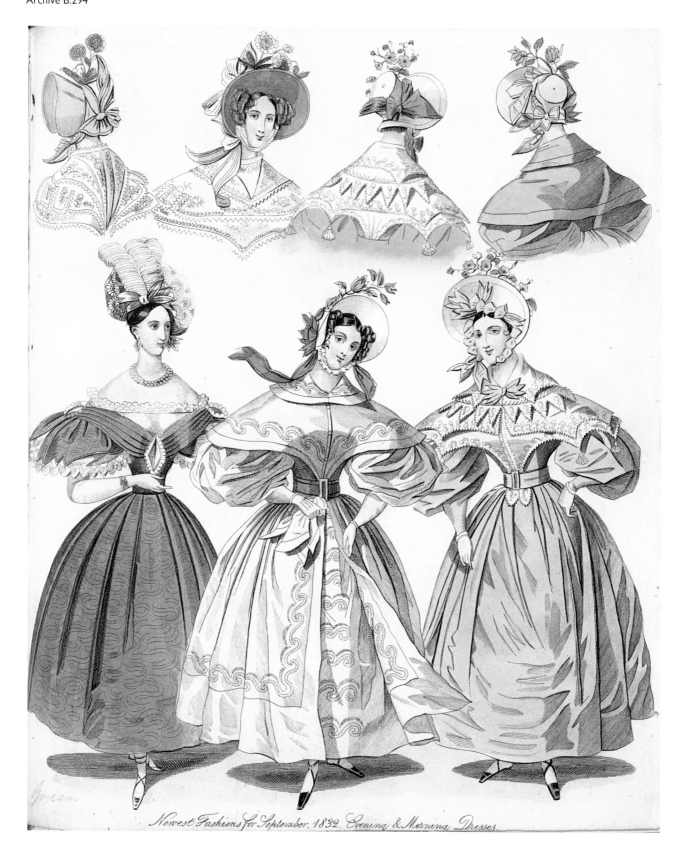

Newest Fashions for September, 1832. Evening & Morning Dresses.

MORNING DRESSES

Morris & Company, *Fruit (Pomegranate)*,
wallpaper sample, 1864. 68.5 × 54.4
(27 × 21½). Archive T.63.1

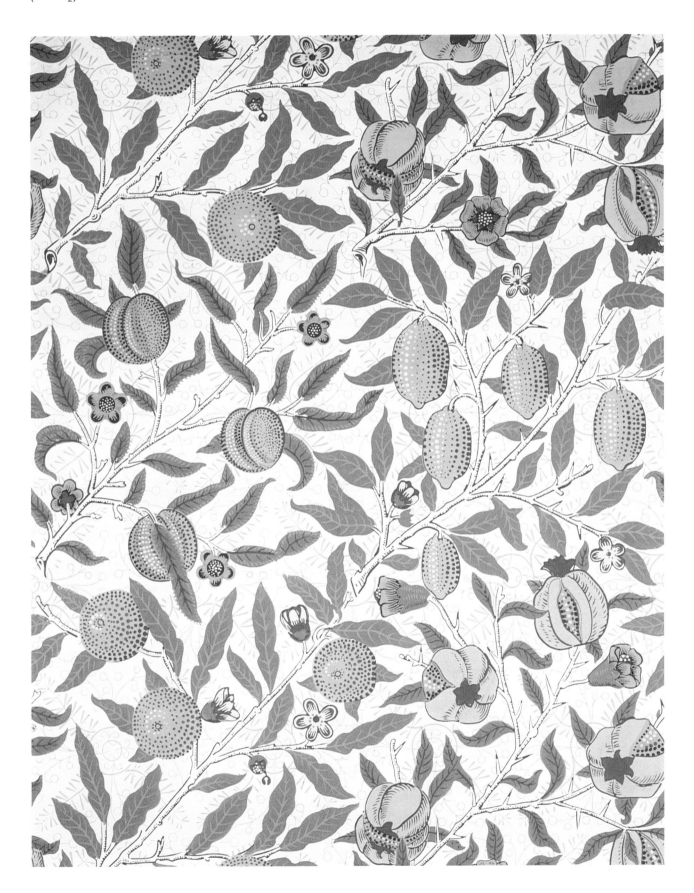

Bernard Meninsky, *Figure in Landscape*,
gouache, 1946. 35 × 70 (13¾ × 27½).
Archive F.139

Justin Howes

Edward Johnston's First Class
at the Central School on 21 September 1899

Justin Howes edited Edward Johnston's *Lessons in Formal Writing* (Lund Humphries, 1986) with Heather Child, and has recently completed a monograph on his Underground types for Capital Transport. He is currently a Research Fellow in the Department of Communication Media, Manchester Metropolitan University, where he is investigating the use by graphic design students of a range of intermediate technologies, including letterpress.

Born in 1872 of Scottish ancestry, Edward Johnston arrived in London when the Arts and Crafts revival was at its height. He came under the influence of W. R. Lethaby and in 1899 started teaching 'Illumination' at the Central School of Arts and Crafts. His first classes laid the foundations for a revival of formal writing in the next century.

It was early in April 1898 that Edward Johnston, then twenty-six, was taken to see the Principal of the newly formed Central School of Arts and Crafts. Lethaby examined Johnston's manuscripts and immediately asked him to write out Browning's 'Over the Seas our Galleys Went' for an American friend. A few days later, on 11 April 1898, Johnston had finished Lethaby's parchment, which he described as 'only three small pages of black-letter with some curly red and blue borders and little enough extrinsically', and 'took it to Lethaby, who seemed to think me very industrious'.[1] In his Diary he noted that Lethaby had 'said he thought of starting an illuminating class at one of the LCC Schools in the winter and that, if all was well, he'd give me the post of Teacher! One night a week at 10s. 6d. Besides the practical help, he said, this would help to make me known. And, when I expressed great pleasure, but thought I was hardly competent, he said – with a laugh – that that was "for the hirer to judge".'[2]

Years later he said, 'Just think of teaching anybody else when I had not taught myself',[3] and spent the next year doing just that. Lethaby, meanwhile, struggled to convince the authorities of the London County Council that illuminating was a useful subject. The first announcement did not appear until 1899, and even then in terms which suggest that there was still scepticism about the class:

ILLUMINATION. – a class for the study of Writing and Ornamentation suitable for Addresses and other MSS. will be arranged if sufficient applications are received. The class will meet, under the direction of Mr. E. JOHNSON (sic), on MONDAY, from 7 to 9.30 in the Embroidery Room.[4]

Sufficient applications must have been received, for at 7pm on Monday, 21 September 1899, seven eager students assembled to hear Johnston in the room usually used by May Morris's embroidery class. What did Johnston tell his students that evening? Two sheets of his notes have survived in the Edward Johnston Collection and Archive at the Crafts Study Centre, Bath.[5] Working from these and from the draft of an essay on 'Good Writing' he wrote for the *Studio* magazine in July 1899, but not previously published, I hope here to reconstruct something of that first – strikingly optimistic – lesson.

Noel Rooke, then eighteen, was in that first class and left a vivid account of it: 'At the first sight of him, although his hands could be seen to be capable, sensitive and strong, the general impression was one of lassitude, of physical strength drained right out. Then he spoke. The clearness and vigour of his mind came as a shock, a delight.'[6]

Johnston started by telling his students that writing was 'a practically lost art, worth reviving' and that they would be making 'an attempt to revive, practically, the almost forgotten crafts of (the) Writer and Illuminator'.[7] Writing was 'worth reviving', he said, 'because it was beautiful and useful'.[8] It was also valuable as a simple and direct craft from which all craftsmen might derive a fundamental theory of making: the 'easiest of all crafts for it needs the simplest tools – which we all have had some practice in using', and one in which the maker could avoid anachronism:

'. . . we may hark back to the best examples and copy boldly if we also copy in an honest spirit – with few modifications and with a little patience and real thoroughness, arrive at beautiful and useful alphabets (beautiful in their directness & unaffectedness, useful in their readableness & their reaction on or suitability (to) other more complex crafts). It is not so with most of the other crafts and by careful copying of more complex design we may learn about methods but not so easily be able to create modern work.'[9]

Johnston went on to say that despite the title of his class, 'Writing and Illumination', he would concentrate on the foundations from which illumination might spring: on letters of the alphabet, on formal writing rather than the applied, medievalising 'illumination' with which he had played as a child. 'The ordinary illuminated address,' he continues, 'is impossible chiefly because the writing in it has for long been suppressed and distorted, because it is, in fact, "Illumination" with some lettering, not, as it ought to be, a page of writing decorated.'[10]

'. . . the Scribe and illuminator must be master of two distinct crafts. One being to write well, the other being to "illuminate" writing. The first branch (being) the more essential and the simpler to grasp, we will consider first, the essential features of good writing.'

He told his students that the 'essential features of good writing' were 'Readableness', 'Beauty', and 'Character' – a famously Johnstonian Trinity which was beginning to replace the terms 'good and true and beautiful' in his thoughts. 'Readableness' alone made a manuscript useful, and from it 'Beauty' would spring:

'. . . a beautiful form enhances the value of a good book or piece of writing, and (the craftsman) can be applying this belief, test the value of his work. He has written out a Book, we will say: has he enhanced its value? If he has made it harder to read – surely not! . . . if he has made it clear to read and naturally beautiful to behold then he has without doubt enhanced its value because while the matter of the book has its worth as before, the form has been made good and true and beautiful!'

'Beauty' was merely the craftsman's 'joy of . . . working made visible to those who know it not', rather than the applied ornament with which it was often confused – a welcome by-product of good work (in a somewhat Utopian society) but no more:

'The Craftsman's end must be to do his work *well*, and he is, or ought to be, convinced that work well done will be correspondingly beautiful.'

'Beauty' was also a moral quality: 'Beauty without truth and goodness is worthless,' he said, 'Beauty joined with untruth and evil, is as Devilish as true Beauty is Heavenly.'

'Character' is Johnston's third essential feature of good writing: a quality of life to be found in making what he later calls 'living letters', and in the aspirant scribe's own 'judgement and taste and some amount of character or personality'.

Moving from principle to practice, Johnston's discussion of writing materials was, even at this early stage, remarkably close to the guidance he gives in *Writing and Illuminating and Lettering*. He told his students that 'a quill pen, Indian ink (and) parchment' were all

they would need to make even the most beautiful work, and that there was no need for them to 'paint in capitals with a brush' or to 'use various inks and colours' or to 'try writing on paper or papyrus . . . or vellum', all of which (however tempting, particularly to students) would distract from the aim 'to maintain a handwriting'. 'By limiting your materials,' he says, 'you limit the physical application and make the work, as is should be, more dependent on its materials' – austere advice, which rings true today.

He handed round quills bought ready-cut from a law stationer, showing how to reshape the point to give a chisel edge. The quill was, he said, 'the most suitable instrument' for formal writing, 'being flexible and capable of being shaped': better, therefore, than the steel pen, more easily obtained than the reed, and more formal than the brush, suitable only for certain kinds of 'lettering'. He then discussed Indian ink ('a jet black which is infinitely preferable to faded or tinted blacks') which he advised students to buy in solution since it 'is somewhat of a trouble to mix and to use', and showed them next how to cut, clean and pounce parchment, 'almost the most adapted material for writing' and, at 2s a sheet, 'comparatively inexpensive'.

So far all had been exposition, discursive and leisurely, building in the class a growing sense of excitement at the thought that they might, as the evening wore on, be allowed to use some of the wonderful materials their teacher was laying out for them.

Johnston himself was not aware of it, but by the time he started writing out the 'simple alphabet' shown in his notes he had captured the hearts and minds of his class, who must have been straining in their seats to see what it was all leading up to. Eric Gill, who joined the class in 1901, wrote eloquently of the effect: 'the first time I saw him writing, and saw the writing that came as he wrote, I had that thrill and tremble of the heart which otherwise I can only remember having had when I first touched her body or saw her hair down for the first time, . . . on that evening I was . . . rapt. It was no mere dexterity that transported me; it was as though a secret of heaven were being

Bottom left
Edward Johnston, Teaching instruction sheet, 1907. 27 × 22 (10¾ × 8¾). Archive MIS 13.3

Bottom right
Edward Johnston, Design for neon tube for 'Shell', 1927. 23 × 19 (9 × 7½). Archive F.77

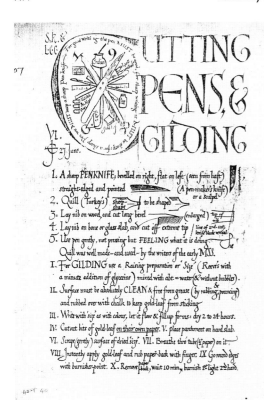

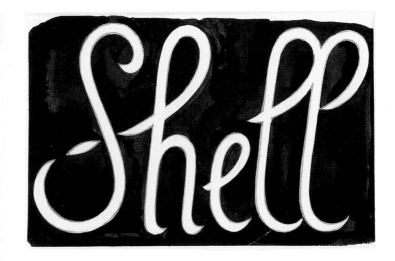

revealed.'[11] Johnston, with the seven students he had won over that evening and those who flocked to his class in the following weeks, was to go on to pioneer a 'revival' in the most literal sense of 'bringing back to life', following the simple message with which he may have wound up that evening:

'The learner must avoid indefiniteness of all kinds. He must set himself a task to master and he must not follow out unnecessary side-issues till he has mastered it.'

Johnston's students this evening seem, from a list he made in his diary,[12] to have been Noel Rooke and Florence Kingsford (both of whom were to make considerable reputations, Florence Kingsford as an illuminator), Miss B. Hacker, David Horne (an architect), Herbert Brownlow, Miss Dickson and Miss Hollinger. Word spread quickly, for by the following Monday he had sixteen students, and an aunt could exclaim delightedly 'how the class grows!'[13] T. J. Cobden-Sanderson (already well known as a binder), Graily Hewitt and Percy Smith joined the class in 1900, Eric Gill in 1901. The Central Saint Martins Art and Design Archive contains one of the few complete series of Johnston's class instruction sheets (MIS.13.1-4, 6-7; MIS.22.1-41, 43-46; MIS.23.1-3), reproduced by the jellygraph process used to copy business letters. Several sheets carry the names of the students who received them, giving a tantalising record of attendance. Various names stand out: Douglas Cockerell attended on 26 October 1899, Adrian Fortescue (later a Roman Catholic priest and noted Arabist) joined Johnston's class on 14 December 1899, but left the following summer to take charge of an Industrial School in Walthamstow: 'I am always hoping to come back, and stick to it till I really can write.'[14] A little later, Rachel Marshall (best known for her wood-engraved illustrations to her husband, David Garnett's, books), Anna Simons (one of Johnston's first pupils at the Royal College of Art), H. K. Wolfenden, Margaret Rooke (Noel Rooke's sister), Miss Stanley and Miss Asquith (who in 1909 took lessons from Johnston at 10 Downing Street) and H. L. Christie (calligrapher) are among those shown attending Johnston's class on 25 November 1907. Another class sheet in the Crafts Study Centre archive shows Harold Curwen – one of the first designers in England of a classically proportioned sans serif type – in attendance on 27 June 1908. Other names are more

Edward Johnston, Special lecture at the Central School of Arts and Crafts, 12 October 1931. Contemporary photograph. Archive MIS 28.66

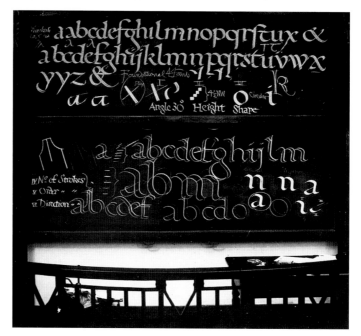

difficult to identify, or come from other sources: that of Helena Hall, for instance, Gill's childhood sweetheart who attended the classes before Gill himself.[15] One is left with the impression of an extraordinarily diverse range of students, many of whose lives were to be permanently changed by their experiences at the Central School. Together they 'made a little band of explorers in unknown country. (Johnston) was the leader of the expedition, but as much an explorer as the rest.'[16]

The best students – notably Graily Hewitt, Noel Rooke and H. L. Christie – themselves soon became teachers, spreading his methods to other LCC schools and further afield. Even Gill occasionally stood in for Johnston when, for instance, he had retreated to Laurencekirk to work on the long-delayed text of *Writing and Illuminating and Lettering*. After one such occasion in 1904 he wrote:

'The Class went off very well I think. I felt less nervous than formerly . . . Miss Lessore wanted to know why her gilded initial was raised on the back of the paper and flat on the front, instead of vice versa as it should have been. I was unable to inform her. Neither could I suggest a remedy. (Woe is me).'[17]

After 1906 it was easier to find the answers to such questions: for in that year Johnston's ground-breaking *Writing and Illuminating and Lettering* was published in the Artistic Crafts Series of Technical Handbooks edited by Lethaby, illustrated by Noel Rooke, and with contributions from Graily Hewitt and Eric Gill.

Johnston gave up his class at the Central School in 1912, prompted by a tidal wave of anti-educative emphasis on student assessment – as now, much favoured by administrators – which had already caused Lethaby to leave. At first he remained in close contact with colleagues at the Central, since at the end of 1912 he joined F. Ernest Jackson and J. H. Mason as one of the editors of *The Imprint* magazine, the first issue of which was introduced by Lethaby on 'Art and Workmanship': 'Every work of art,' Lethaby wrote, 'shows that it was made by a human being for a human being.'

Graily Hewitt took over Johnston's class at the Central School, explaining, 'I want them to let me stand out again, that you may return . . . I hope the post may keep open for you practically, and this arrangement is really temporary.'[18] Johnston was not to teach again at the Central School until the 1930s when he came back as a guest lecturer. His daughter Priscilla recalled 'a dim impression of the largeness of the hall and then the surprise of seeing him on the platform – in the familiar old herring bone suit with the bulging pockets . . . reaching up to make his great sweeping chalk lines on the huge blackboard.'[19] His blackboards on these visits were photographed by one of his assistants at the Royal College of Art, Violet Hawkes. The Archive contains a set of her photographs of Johnston's blackboards at both the Royal College of Art and Central School (MIS.28.1-110).

Heather Child has remarked that Johnston had two particular gifts: one for perceptive and painstaking research into the pen-shapes of letters and the principles and methods of medieval scribes, the other for communicating his findings in teaching of inspiring quality. At a time when further education is under threat, and when in particular design education is threatened on all sides by short-termism and managerial disease, it becomes particularly important – for students and teachers alike – to rediscover the qualities of personal integrity and vision which so clearly run through Johnston's teaching and that of his colleagues at the Central School of Arts and Crafts. The Central Saint Martins Art and Design Archive can be of much more than merely historical interest: it records a remarkable and revolutionary episode in education, and one whose ideas are far from having been fully played out. It is a resource, I believe, from which present-day educators have much to learn.

1. Edward Johnston's MS *Notebook of Poems with 'Red Letter Days',* 4-11 April 1898. Private collection.

2. ibid.

3. Edward Johnston, lecture at the Royal College of Art, 18 May 1931.

4. Central School of Art and Crafts Prospectus, 1899, p.7.

5. Illustrated in Heather Child and Justin Howes (eds), *Edward Johnston: Lessons in Formal Writing,* Lund Humphries, 1986, p.83.

6. Priscilla Johnston, *Edward Johnston,* Faber and Faber, 1959, pp.98-9.

7. ibid., p.97 quoting an undated sheet of notes possibly dating from after June 1900, when Johnston read the manuscript of T. J. Cobden-Sanderson's *Ideal Book of Book Beautiful.*

8. ibid., p.97.

9. Edward Johnston, notebook in Harry Ransom Humanities Research Centre, c.1901.

10. Priscilla Johnston, op.cit., p.79.

11. Eric Gill, *Autobiography,* Lund Humphries, 1992, p.119.

12. Sun Alliance Assurance Diary for 1900. Crafts Study Centre.

13. Priscilla Johnston, op.cit., p.30.

14. Adrian Fortescue, letter to Edward Johnston, 11 December 1900. Private collection.

15. Fiona MacCarthy, *Eric Gill,* Faber and Faber, 1989, p.38.

16. Priscilla Johnston, op.cit., p.98.

17. Eric Gill, letter to Edward Johnston, 13 June 1904. Private collection.

18. Graily Hewitt, letter to Edward Johnston, 7 September 1912.

19. Priscilla Johnston, op.cit., pp.279-80.

Sylvia Backemeyer

The School of Book Production and Its Influence

whence cometh my help. My help
cometh from the Lord, which
made heaven and earth. He will
not suffer thy foot to be moved:
he that keepeth thee will not
slumber. Behold, he that keepeth
Israel shall neither slumber nor
sleep. The Lord is thy keeper: the
Lord is thy shade upon thy right
hand. The sun shall not smite thee
by day, nor the moon by night.
The Lord shall preserve thee from
6

Page 6 of *Three Psalms, LVI, CXXI, CXLII*,
printed and bound at the Central School.
Blocks drawn and cut by Vivien Gribble,
1922. 38 × 25 (15 × 10). Archive P.804

In 1916 *The Studio* was able to report of the Central School: 'A book can be produced in
its studios and work rooms complete in every respect – printing, illustration and
binding.' When the new Central School building in Southampton Row was planned it
was considered essential that the accommodation should be arranged so that classes
dealing with related subjects should be grouped together. Thus Architecture and
Building Crafts, Architectural Design, Letter Cutting in Stone, Ironwork, Leadwork,
Decorative Plasterwork, etc. were all grouped together on one floor. In the detailed
schedule for the new building which Lethaby provided for the Technical Education
Board in 1903, there was provision for a School of Book Production on the second
floor of the building of 7,250 square feet with space for printing, engraving, colour
printing, writing and illuminating, lithography, drawing and design, and a laboratory for
testing materials. The schedule for book production was accompanied by a report by
Douglas Cockerell. 'It is not of course suggested that printers should learn book binding
or binders printing, but that it would be an excellent thing if these and other allied crafts
could be brought together under a general head so that by mutual interchange of ideas
between the masters and pupils of the different classes the relative needs of each of the
crafts might come to be generally understood.'[1]

These views would have had Lethaby's blessing as they were very much in line with
his own philosophy of demystification and the need for students to understand the links
between their own and other crafts in order to do their own work more intelligently.
The awareness of the needs of bookbinders by printers, and vice versa, affected the
choice of paper, the proportions of margins, and the placing of text and illustrations on
the page, and thus led to a much more aesthetically pleasing end-product. Master
bookbinders and printers such as Sangorski and Sutcliffe valued Central School-trained
students precisely for this reason.

The first classes in Book Production were held at Bolt Court Technical School in
1895. They were moved in 1896 to the newly founded Central School of Arts and
Crafts at Morley Hall, Regent Street. Douglas B. Cockerell established the first
Bookbinding classes in 1895 but it was not until 1905 that they were joined by Printing.
Cockerell had been trained at the Doves Press by T. J. Cobden-Sanderson who was an
advisor to the newly established course and gave a series of technical lectures with
lantern slides. A member of the Art Workers Guild, Cobden-Sanderson, like
J. H. Mason, was designated one of the original group of Royal Designers for Industry
created by the Royal Society of Arts in 1938. Cockerell taught Bookbinding at the
Central from 1897-1904 and continued as a visitor until 1935. He suggested a scheme of
lectures on materials and methods, some for binders, others for the whole School of
Book Production, showing understanding of the apprentices' capabilities. He suggested

that lectures should be short, not too frequent, and where possible in the nature of demonstrations.

From the start Bookbinding was one of the best attended classes. 'In the case of the bookbinders the average attendance is the highest yet reached, 88 attendances made this week or 22 per class meeting.'[2] Bookbinding was one of the classes which excluded women. The Central School was under pressure from trade organisations to exclude women from Bookbinding and Silversmithing classes. On one occasion, a prospective female Bookbinding student was informed by the Central School that both the bookbinders and silversmiths trades had threatened to withdraw all their men from the class if women were admitted.

Both Douglas Cockerell and J. H. Mason, who was appointed to teach Printing from 1905, were from the Doves Press. They had worked together on some of the finest productions for this famous private press, including the five-volume *Doves Bible* and Cobden-Sanderson's *Ideal Book*. Two other men who came to the Central School from the Doves Press were E. P. Prince, the punch cutter, and Peter Mcleish, who took charge of the Bookbinding on the retirement of Cockerell. One of Lethaby's greatest contributions to art education was the revival of dying crafts. He recognised that 'The private press movement was doomed to ultimate failure unless those sound principles of craftsmanship which it had rediscovered could be taught again and applied to an industry which was rapidly being transformed by the age of the machine.'[3] The Doves Press relied upon quality of materials and superiority of setting and press work to create a simple but excellent effect. This must have greatly appealed to Lethaby.

The books printed and bound at the Central School were very much influenced by the Doves Press. Morocco was the favoured leather, dyed in brilliant, jewel-like colours. Although a few of the binding designs are elaborate, the majority are simply tooled. Many of them have a line border, sometimes round a panel, sometimes interspersed with dots. Simple motifs such as wreaths or sprigs of flowers feature. Often the author and title appear on the spine and not on the front. The endpapers are sometimes marbled paper, others are leather doublures. The majority are plain. Several titles are bound in different ways to illustrate different techniques. Inside the back cover is tooled the name of the student responsible, the tutor and the date. Simplicity is also the keynote of the printing, the placing of the type on the page taking priority. Almost all the Central School printing under Mason is in Caslon Old Face. Very little decoration is used apart from the occasional ornamental letter, usually in red. Wood engravings were sometimes used as a frontispiece, on the title page or in the text. Noel Rooke taught and supervised Wood Engraving for printed books from 1914.

The choice of titles for printing, as one would expect from Mason, are mainly classics of European literature, including some translations from the French and Italian. Mason acquired some Caslon Greek Type which was used with a facing English translation. *The Iliad, Hesiod Works and Days* and *Lucian's Dream* were all printed by the Central School, the only school where Greek and Hebrew printing were taught. The aim was to lessen the need for books in these languages to be printed abroad.

The LCC used the School of Book Production to redesign official publications, such as the 'blue book', and to print and bind official and commemorative sheets and volumes, such as 'Message from the King', which celebrates twenty-five years of the reign of George V. A beautiful edition of Stow's *A Survey of London* was produced in 1929, using the skills of binders, printers and book illustration students.

A considerable number of books in the collection have been rebound by the students. This may have been an aspect of the Cleaning and Repairing Books class started in 1900 which covered conservation, maintenance and rebinding. Rebindings were often more

elaborate than the binding of books printed in the School, possibly because the contents in most cases were not so simply set and printed. One of the finest is a *Herbarium* in Latin (Mainz, 1484). Illustrated with hand-coloured woodcuts, this was rebound by two students in 1910 in calf on oak boards inlaid with rosewood. Another, remarkable for its size, 66 × 55 cm, is *Cathedrals, The Works of Roger Fenton*, a collection of photographs bound in 1911 by a student in the Day Technical School. In 1912 the LCC Consultative Committee on Book Production under the Chairmanship of Emery Walker mounted an exhibition of work done by students of London schools including the Central School of Arts and Crafts. Interestingly, the students' work was shown alongside private press books, and rare and early printed books.

The Day Training School of Printing, which opened in 1909 in the new Southampton Row premises, was the only school at that time designed to give full-time craft training together with general education at secondary level. It ran alongside the evening classes that had been held since 1905. 'It is open to receive boys between thirteen and fourteen years of age who are in good health and can show evidence of a satisfactory preliminary general education and fitness for the printing trade . . . The boys receive trade instruction together with general education and physical exercises and are trained until the age of sixteen. On or about their fourteenth birthday they should be indentured to master printers . . . Master printers are therefore invited to apply to the School when they have openings for apprentices.'[4]

The Printing classes, like those in Bookbinding, were extremely successful and rapidly found favour with the industry. Very soon St Clement's Press and the Baynard Press and other enlightened concerns were taking the majority of their apprentices from the School and with the co-operation of the trade unions, the time spent at school following the boy's fourteenth birthday until his joining the firm at approximately sixteen years counted towards the completion of the then very lengthy apprenticeship of seven years' duration.'[5]

At least forty students taught by Mason became part of printing education in this country and in their turn passed on the skills learnt at the Central School: W. H. Amery, Camberwell School of Arts and Crafts; Leonard Jay, Head of School of Printing, Birmingham; Leslie Owens, Principal, London College of Printing; Charles Pickering, first HMI to be appointed as national specialist for printing subjects; F. P. Restall, Heriot Watt Printing Department, Edinburgh; and J. H. Wright, a lecturer at the Central and at Camberwell. A. J. Cullen, a pupil of Mason and for many years his deputy, took charge of the School of Printing on Mason's retirement in 1940. Annual summer schools were run at the Central School for many years which enabled teachers of layout and typographical design to take refresher courses.

J. H. Mason was an extraordinary character. He was a linguist who had taught himself Greek and Latin and through his love of the classics and English literature obtained the key to a rich cultural life which coloured all his work as a printer. Chief compositor of the Doves Press from about 1900, he was invited by Lethaby to take over the School of Printing on a full-time basis from 1909. He had taught part-time since 1905 as well as establishing the Printing School and developing the work of the department to a very high standard. In addition to his work in the School of Book Production, Mason had several other interests which helped to further the cause of good printing.

In 1913, together with Gerald Meynell of the Westminster Press and F. E. Jackson and Edward Johnston of the Central School, Mason published a new trade journal, *The Imprint*, which they saw as a vehicle for carrying the ideals and practices of the best of the private presses into the general printing trade. Mason designed a new type face for the journal as he did not think Caslon Old Face suitable for a periodical. 'Imprint Old

John Stow, *A Survay of London*, title page. Printed at the School of Book Production, 1929. 35.5 × 24.5 (14 × 9¾)

A SURVAY OF
LONDON
CONTEYNING THE ORIGINALL, ANTIQUITY
INCREASE, MODERNE ESTATE, & DESCRIPTION
OF THAT CITY, WRITTEN IN THE YEARE 1598
BY JOHN STOW
CITIZEN OF LONDON. SINCE BY THE SAME
AUTHOR INCREASED, WITH DIVERS RARE
NOTES OF ANTIQUITY, AND PUBLISHED IN
THE YEARE, 1603. ALSO AN APOLOGIE (OR
DEFENCE) AGAINST THE OPINION OF SOME
MEN, CONCERNING THAT CITIE, THE GREAT-
NESSE THEREOF. WITH AN APPENDIX, CON-
TAYNING IN LATINE LIBELLUM DE SITU ET
NOBILITATE LONDINI: WRITTEN BY WILLIAM
FITZSTEPHEN, IN THE RAIGNE OF HENRY II
M DC III
PRINTED AT THE LONDON COUNTY COUNCIL
CENTRAL SCHOOL OF ARTS AND CRAFTS
MCMXXIX

A NOTE BY WILLIAM MORRIS ON HIS
AIMS IN FOUNDING THE

KELMSCOTT PRESS

TOGETHER WITH A SHORT HISTORY
AND DESCRIPTION OF THE PRESS BY
S. C. COCKERELL REPRINTED *for* PHILO-
BIBLON *to* CELEBRATE THE CENTENARY
OF THE BIRTH OF WILLIAM MORRIS

1834 : 1934

Large Paper Edition second Printing

WILLIAM MORRIS

ENGRAVED ON WOOD By John FARLEIGH

LONDON COUNTY COUNCIL
CENTRAL SCHOOL OF ARTS & CRAFTS
SOUTHAMPTON ROW, LONDON, W.C.1

A Note by William Morris on His Aims in Founding the Kelmscott Press, printed and bound by the Central School of Arts and Crafts, 1934. 31 × 23.5 ($12\frac{1}{4}$ × $9\frac{1}{4}$)

Face, as the new type face was called, was cut by the Lanston Monotype Corporation at our insistence. We are exceedingly pleased with it and congratulate the Monotype Company on having produced the finest face that has been put on the general market in modern times . . . Though cut for *The Imprint* it is on sale to the general public . . . for our policy is sincerely to improve the craft of which we are so proud.'[6] The first issue opens with an article by Lethaby, 'Art and workmanship', which calls for the application of craft standards to all man-made things.

Another of Mason's projects undertaken every summer from 1908 to 1914 and again from 1925 to 1933 was his work for Count Harry Kessler in Weimar at the Cranach Press. He set a number of important works for the Press including *Hamlet* with woodcuts by Gordon Craig. Kessler was one of the men responsible for the revival of printing in Germany. He persuaded Mason, Eric Gill, Edward Johnston and Emery Walker to help him set the standards for the Cranach Press. This Central School connection with Germany was one of several which was influential in improving German printing. Edward Johnston's student Anna Simons became the chief teacher of his methods in Germany. Muthesius and Gropius both recommended German students to study at the Central School, and the Deutsche Werkbund founded in 1907 had many of the same aims as Lethaby and the early Central School. Ironically it took the British printing industry much longer than their German counterparts to adjust to the new developments.

The collection of books printed and bound in the Central School is extensive. As the work of the Book Production School was never sold commercially and the books were only produced singly or in small quantities, its importance has never been assessed or compared with that of the private presses. 'Its typical product, expertly printed, had the simplest typography, close settings in Caslon . . . and sometimes straightforward black and white illustrations. It exactly embodied Lethaby's notions of a work of art. Its significance lay not in itself but in the standard of quality that it embodies. The classes were founded to train workmen . . . who took away with them what they had learned and diffused it into the world of commercial printing.'[7]

1. *Technical Education Board Minutes*, March 1903.

2. *Technical Education Board Minutes*, January 1902.

3. Mason's notes, quoted in L. T. Owens, *J. H. Mason, Scholar Printer*, Muller, 1976.

4. Central School of Arts and Crafts, *An Account of the Printing Department*, LCC, 1928.

5. Mason's notes quoted in L. T. Owens, *J. H. Mason, Scholar Printer*, Muller, 1976.

6. *The Imprint*, Vol.1, No.1, January 1913.

7 Godfrey Rubens. 'W. R. Lethaby and the Revival of Printing', *Penrose Annual*, 1976.

Joanna Selborne

The Wood Engraving Revival

Joanna Selborne graduated from the
Courtauld Institute of Art in 1973 and
completed her PhD in 1992. She is writing
a book for Oxford University Press on
*British Wood Engraving Book Illustration,
1904 to 1940.* Among other subjects, she
has also written on Gwen Raverat and the
St Dominic's Press.

In 1936 Campbell Dodgson, Keeper of Modern Prints at the British Museum, noted how much the modern progress of wood engraving was due to Noel Rooke's skilful tuition at the Central School.[1] By this date few wood engravers had not come under his influence, either directly or indirectly. Through his attempts to transform the medium from an imitative process as practised in the nineteenth century by professional cutters and used, for instance, in many of the Kelmscott Press books, to an autonomous art form, exemplified by John Farleigh's white-line portrait of William Morris for the frontispiece to a Central School edition of his work, Rooke helped to raise the status of wood engraving as an independent graphic medium. Yet, for all his innovative steps, wood engraving, in contrast to etching, remained firmly entrenched in the bookmaking tradition of the school. In keeping with its original function 'to provide specialised art teaching in its applications to particular industries',[2] classes came under the Department of Book Production and Printing before this department was incorporated with Graphic Art in the 1950s. It was left to Rooke's pupils and their contemporaries to interest the wider public in single prints, both through teaching and through exhibitions, particularly those held by the Society of Wood Engravers (founded 1920) and the English Wood Engraving Society (founded 1925).

At the turn of the century wood engraving was rarely taught at the few existing art schools and then only by reproductive engravers such as W. H. Hooper or R. J. Beedham, instructor at Bolt Court School of Photoengraving and Lithography. In 1904, after attending part-time classes at the Slade School from 1899 to 1903, Rooke joined Beedham's classes. Dissatisfied with photo-mechanical process as a means of artistic expression, he resorted to wood engraving, having been encouraged by Lucien Pissarro to experiment with techniques, including graduated printing, woodcutting on the side-grain of boxwood and colour printing. With a wide knowledge of both original and process engraving, Rooke concluded 'that wood engraving offered the best means of book decoration and illustration for the future, but on condition that it was done from a new point of view'.[3] This he discovered through Edward Johnston's revolutionary illuminating classes which he attended from 1900 to 1905; Johnston's credo that an art work must depend on the nature of the tool used inspired him to make engravings on wood on the same basis. Lethaby's emphasis on workshop training and the direct handling of tools and materials (of particular relevance to wood engraving) furthered Rooke's cause.

By his own account, he initially met with opposition in his attempts to introduce creative wood engraving into the curriculum. Until Lethaby's departure in 1911 he was only able to teach it by slipping it covertly into his Illustration classes which he took from 1905. Lethaby, however, would not have disapproved of the medium *per se* since

he was always trying to revive or preserve dying crafts. Colour woodcutting was enjoying popularity at the time[4] and a class in 'Woodcuts in Colour and Wood Engraving' under Sydney Lee may well have been one reason for not introducing another class. Lethaby was doubtless also aware of the demands of commercial publishers who were heavily committed to process methods of illustration and were generally unconcerned with fine printing. Ironically the purist approach which J. H. Mason, Head of Printing at the Central School, gained from working with Emery Walker and Cobden-Sanderson at the Doves Press, may well have been an obstacle to Rooke. He admitted that at first Mason's teaching received considerable criticism for its lack of flamboyance and its simplicity.[5] Certainly a study of the books produced under his direction from 1906 reveals a limited amount of illustration; mainly black-line wood engraving, with occasional initials designed by the Book Illustration class. Not till about 1912, by which time Rooke was responsible for teaching lettering and wood engraving in the Day Technical School, and from 1914 when he became Head of the School of Book Production and taught both woodcutting and wood engraving under the general heading of 'Woodcutting for Reproduction', did the illustrations become more sophisticated, as for instance Vivien Gribble's for *Three Psalms* and *Cupid and Psyche*.

The slow recognition of wood engraving as an acceptable art school subject was indicative of the conventional attitudes facing aspiring young wood engravers at the time. Yet from within the confines of Rooke's class, affectionately known as 'The Rookery', there quietly emerged a whole new discipline in which illustration played a central part. Rooke made a lasting impression on his students, among them Leon Vilancourt who remembered 'his precision as a teacher, not simply in the manipulation of techniques, but far more important, in the wide far-reaching skill of research for reference materials and general literary preparation of the students' minds'.[6] His importance in encouraging pupils to break into the world of publishing cannot be too strongly emphasised. Although interested in letterpress, unlike Morris he also advocated

Noel Rooke, *Two Bridges*, wood engraving, 1914. 15.7 × 18 (6¼ × 7)
Archive P.344

modern printing techniques, in line with the leaders of the typographical renaissance which flourished between the wars. These included modern-minded printers and typographers such as Emery Walker, Gerard Meynell, Bernard Newdigate and Stanley Morison, and owners of the newly emergent private presses, in particular the Golden Cockerel, the Gregynog and the Nonesuch Presses.

Some of the more enlightened commercial publishers, as well as printers like Oliver Simon of the Curwen Press, and Walter Lewis of Cambridge University Press were moved to use wood-engraved illustration as a result of the fine work emanating from the Central School and the success of illustrated private press books. The proliferation of typographic journals such as *The Imprint* and *The Fleuron*, and periodicals which included wood engravings by Rooke and his pupils all helped to put their work on the map. Prints by Ray Marshall, M. Berridge, Margaret Pilkington, Herbert Rooke, Vivien Gribble, Millicent and Muriel Jackson, Margaret Haythorne, Celia Fiennes, Robert Gibbings, Mabel Annesley, Clare Leighton, Marcia Lane Foster and John Farleigh, among others, were reproduced in specialist productions published between 1919 and 1930, including Malcolm Salaman's *Modern Woodcuts and Lithographs* (1919), *The Woodcut of Today at Home and Abroad* (1927), and *The New Woodcut* (1930), all published by Studio Publications, Campbell Dodgson's seminal *Contemporary English Woodcuts* (1922), and Herbert Furst's *The Modern Woodcut* (1924). Through his wide knowledge of the publishing industry Rooke was able to procure commissions for his pupils. For instance, he recommended Ray Marshall to Chatto & Windus and introduced Farleigh to Gibbings

Celia M. Fiennes, *Eagle and Cock*, wood engraving, undated. 4.5 × 8.5 ($1\frac{3}{4} \times 3\frac{1}{4}$). Archive P.422.3

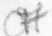

and Basil Blackwell, resulting in illustrative work for the Golden Cockerel and Shakespeare Head Presses.

Most of Rooke's better known pupils went on to produce single prints and ephemeral work as well as book illustration and wood engraving for publicity purposes. Some but not all are represented in the Archive. One of his first and most distinguished pupils, Robert Gibbings, bought the Golden Cockerel Press in 1924. He contributed a large amount of his own wood-engraved illustration to its publications, also employing a wide variety of artists, some from the Central School, including Rooke, his wife Celia Fiennes, Farleigh and Annesley. Several of Gibbings's modernist wood engravings, among the most striking graphic images of the period, are held in the Archive. Examples of the work of Rooke's pupils mainly known for their book illustration, notably Ray Marshall, Vivien Gribble, Lynton Lamb and Margaret Pilkington, are listed, although prints by Annesley and Lane Foster are not, nor are examples by Helen Binyon, Dorothea Braby, John Petts and John O'Connor, all Golden Cockerel illustrators chosen by Christopher Sandford, Gibbings's successor at the press from 1933. The work of Clare Leighton, one of the most popular wood engravers to emerge from the Rookery, is also conspicuous by its absence. Owing to pressure of teaching and his dedication to helping his students, Rooke's own output was small, and only a few examples of his wood-engraved prints remain in the collection. His robust handling and the weighty predominance of black were characteristics much imitated by his early pupils at a time when experiment and the 'courage to be crude' was in the air.[7]

Below
Robert Gibbings, *Dublin under Snow*, wood engraving, 1919. 9.1 × 24.3 (3½ × 9½). Archive P.1139.7

Bottom
John R. Biggs, *A Rainy Day*, wood engraving, 1935. 22.5 × 10 (8¾ × 4). Archive P.348.2

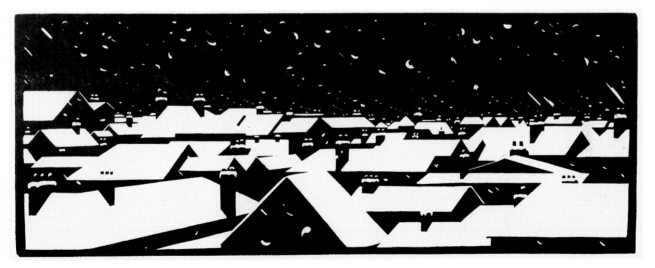

Margaret Pilkington, *Duck Pond*, wood engraving, 1914. 14×9 ($5\frac{1}{2} \times 3\frac{1}{2}$). Archive P.577.1

1. Letter of reference to the Central School of Arts and Crafts recommending Rooke for the post of Principal, 11 March 1936. Held by Celia Rooke.

2. *Technical Education Board Minutes*, 1896, p.156.

3. From notes written by T. M. Rooke. Held by Celia Rooke.

4. Mainly due to the experimental work of J. D. Batten who, with Frank Morley Fletcher (taught 1899-1904), pioneered the Japanese method in England.

5. L. T. Owens, *J. H. Mason 1875-1951, Scholar Printer*, Muller, 1976, p.68.

6. Leon Vilancourt to the author, 16 January 1986.

7. Quoted from Douglas Percy Bliss, 'The Last Ten Years of Wood-Engraving', *Print Collector's Quarterly*, 21, 1934, p.253.

For many years teacher of antique and still life drawing in the Book Production Department, Farleigh succeeded Rooke as head of the department in 1947. His vociferous proselytising and forging of links with industry were highly effective means of furthering the cause of wood engraving. Although not officially employed to teach the medium, following in Rooke's tradition of technical and experimental development he nonetheless managed to inspire practitioners, among them Monica Poole. With a finer line than Rooke's, his late style at times verging on the abstract or surreal, Farleigh's influence in this direction is evident from examples of student work of the 1930s. His own prints are well represented, including an early landscape and illustrations to Bernard Shaw's *Short Stories, Scraps and Shavings*, and a fine coloured lithograph of *Melancholia* based on his wood engraving of the same title.

It is interesting to note the number of female artists listed. In the early days this was perhaps partly due to the fact that they were excluded from classes such as Bookbinding and Silversmithing, as the trades did not admit women. Also, at a time when women were finding it hard to make their mark as painters, wood engraving provided a practicable small-scale alternative.

Although by no means comprehensive, the Central School Archive enables a valuable overview of the wide diversity of wood engraving styles and techniques which evolved over half a century. In accordance with Lethaby's principle that artwork ought to relate to the world of production, and his emphasis on the use of the Teaching Collection consisting of artefacts as varied as incunabula, Kelmscott Press printing, natural history books, fashion plates, and Bewick prints as a basis for design, the range of subject matter is, not surprisingly, relatively orthodox; mainly figures, flowers, birds, and animals, town or country views, and seascapes, in general portrayed in a distinctively English vein. Only a few artists make a point of social commentary, Hilda Quick's series of working people being powerful examples. The number of narrative scenes and decorative images represented indicates the value placed on illustration and book-related design of several stylish repeat-pattern papers designed by F. Graham, Sheila Hutchinson and Alice M. Hindson as endpapers; some were used as covers to music published by Oxford University Press. Various images were clearly intended for publicity purposes, as were a few by John Biggs.

Noel Rooke's radical approach to wood engraving and the desire to integrate art into industry had strong repercussions on the movement as a whole, breaking down old divisions and encouraging new practitioners and collectors. Yet his influence was not just confined to the medium itself. As a result of his efforts similar developments arose in the field of block-printed textile design. For its part, wood-engraved illustration, printed simultaneously with type, enhanced the quality of the printed page and, in combination with new typography, affected the standards of book production and other printed matter. After World War Two, however, the temporary demise of the Society of Wood Engravers, together with the introduction of new, more cost-effective printing technology and a demand for colour illustration, led to a decline in the use of black-and-white wood engraving in books or as collectable works of art. Gertrude Hermes, who taught part-time from 1947, helped to keep the interest alive at the School until the 1960s, one of her most promising students being Sarah Van Niekerk. Similarly the presence of Blair Hughes-Stanton, one of the most respected wood engravers of the period, as a teacher of life drawing must have provided inspiration for many pupils. Since the 1980s wood engraving has undergone another revival, most especially in the field of commercial art; for magazines, as advertisements, and on supermarket packing – art for industry in the true spirit of the early Central School philosophy.

A. Jean E. Brown

1920s German Film Posters

Jean Brown is currently a Senior Lecturer
on the MA Conservation of Fine Art
Programme at the University of
Northumbria at Newcastle. She has
carried out extensive conservation work
on the German Film Poster collection
held by the Archive at Central Saint
Martins College of Art and Design. She
was previously Head of Paper
Conservation at the National Museum of
Wales, Cardiff, prior to which she
worked in the Western Pictorial Art
Section of the Department of
Conservation at the British Museum. She
has also worked extensively as a freelance
conservator and a Visiting Lecturer at
Camberwell College of Art, London.

The German film posters held by Central Saint Martins College of Art and Design relate to a number of films produced in Berlin by UFA during the early 1920s. Posters are more than just aesthetically pleasing images; they are essentially a means of communication. Much of their interest therefore lies in what they are communicating and how that is brought about. In order to understand the significance of the collection we must look at the film and advertising industries in Germany during that period, together with the background from which they emerged.

The beginning of the European film industry is generally credited to the Lumière brothers who gave a public showing of their patented Cinematographe in France in 1895. The German film industry began in November of the same year when the Skladanowsky brothers showed their Bioscope at the Wintergarten in Berlin. Both the Bioscope and the Cinematographe were quite crude, judged by today's standards. Improvements in design and capability followed rapidly, largely due to entrepreneurs such as Oskar Messter who quickly realised the enormous potential of the new entertainment medium. Messter's involvement in film started in 1896 when he began making projectors. These were soon followed by cameras and by 1897 he was making the first films in his own studios.

Most early German films were shown in mobile cinemas at fairs. They proved so popular that more permanent cinemas were quickly set up in empty shops. Shop cinemas offered the most basic facilities: a few rows of seats, a projector and a screen. The film was accompanied by a piano or gramophone and a spoken commentary. It was not until 1907 that subtitles were introduced. The magic of the moving film made it an immediate success and purpose-built cinemas were soon being constructed to accommodate the growing numbers of people who wanted to 'go to the cinema'. The growing demand resulted in a rapid expansion in both film production and film production companies. By 1908 the first International Cinematographic Industry Exhibition was held in Hamburg. By 1911 there were eleven film production companies in Germany and over 130 cinemas in Berlin alone. Most of the films shown were foreign, not German, partly because demand had quickly outstripped the capacity of the developing German film industry, and partly due to the superior quality of the films made by Pathé and Gaumont. The poor quality of some early German films was due to a lack of support from the government and from theatre directors, and because members of the church and educational establishments attacked them on moral grounds. The Association of Berlin Theatre Directors banned stage actors from taking roles in films. (In response the film companies imported foreign actors.)

Despite these early problems, films were very popular and by 1913 the cinema was the main source of public entertainment. Gradually investors, as well as groups of

writers and intellectuals, began to recognise the potential of film. The outbreak of war in 1914 did not crush the fledgling industry as might have been expected. On the contrary, it was during the war years that it finally became fully accepted and established, partly because of increased public demand for escapism, but also from a recognition of the potential for propaganda in the film medium.

In November 1917 a radical step was taken which determined the future development of the German film industry. A number of comparatively small companies involved in the production, distribution and screening of films amalgamated with the foremost bank in Germany to form the Universum Film company, UFA. UFA was floated with a pure gold capital of 25 million marks which was increased to 100 million marks in the spring of 1921. This was partly provided by the Deutsches Bank and partly by the Reich. In late 1921 the company was fused with Decla Bioscope and the funding increased to 200 million marks. It was further increased in 1923 to a staggering 300 million marks, the equivalent of £15,000,000. The level of involvement and the scale of the financing was unparalleled anywhere else in the world and it provided UFA with the power to project itself into the top league of film production; UFA quickly became the most prolific film company.

The talent brought together by UFA was phenomenal: directors such as Ernst Lubitsch, Oskar Messter, Friedrich Wilhelm Murnau, Erich Pommer, Joe May, Fritz Lang and Paul Wegener; screenwriters such as Hans Krähly and Robert Herlith; cameramen such as Theodor Sparkühl and Fritz Arno Wagner; and stars such as Henny Porten, Ossi Oswalda, Mia May, Hermann Thimig, Pola Negri, Emil Jannings, Eduard von Winterstein, Harry Liedtke and Bernard Goetzke. UFA began a programme of film production during the 1920s that was unprecedented in Europe. The number and variety of films produced was huge and broad-ranging: big historical costume dramas, films based on literary works, thrillers, modern dramas, natural history films, films of elucidation, fairy tales and folk legends. Developments in the art world also impacted on film-making. This can be seen most clearly in films involving fantasy, which lent itself to a less naturalistic interpretation. Among the greatest exponents of the new Expressionist cinema were directors such as Fritz Lang and Paul Wegener. In 1923 UFA published a book about the company and its achievements. This covered: the organisation of the company and the construction of its various sites; an overview of the German film industry, its directors and stars; and film press reviews. The book was published in English, French and Italian as well as German and was both a statement of, and testament to, the confidence, influence and power of the German film industry at this time.

By the 1920s advertising was well established throughout Europe, following the development of increasingly competitive markets for leisure services and manufactured products. Poster design was in the forefront of these developments and training courses and books were available to artists wishing to specialise in specific fields. Despite this level of activity the overall approach often remained fragmented, concentrating on a particular aspect of design or the requirements of specific industries, rather than addressing concepts of effective design in their own right. This can be seen in both Haufstengel's *Die Reklame des Maschinenhaus*, 1923, and Koesschauer's *Leitfaden für Film Reklame*, 1924. The latter is particularly interesting as it contains examples of work by many of the artists of the posters in the Central Saint Martins collection.

The increased level of activity within the advertising world resulted in the development of new ideas regarding poster design. The work of both the Beggarstaff Brothers and Holwein, before and during the war, had shown the effective use of a less naturalistic approach. Their designs showed the impact of a strong outline together with flat masses of colour. At the same time there was an increased awareness of the visual

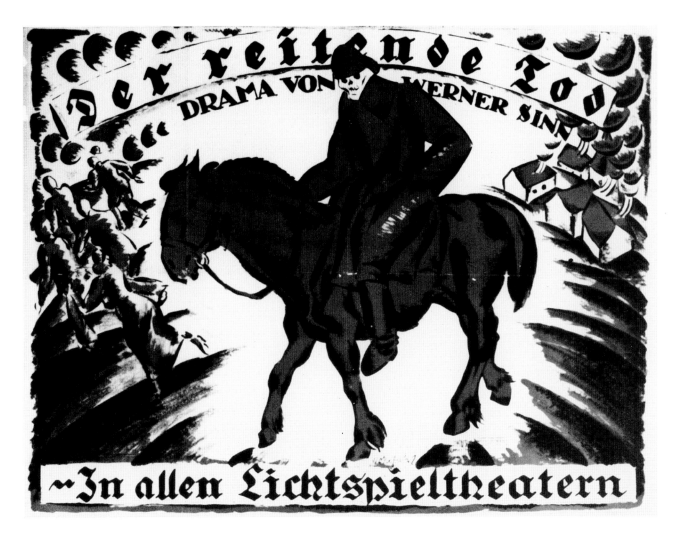

Der reitende Tod, UFA, Berlin, 1920s.
71.8 × 95.4 (28¼ × 37½). Archive POS.960

power of letterforms and in particular their relationship to the image. Although it would be premature to use the term graphic art at this stage, these were its formative years. The new developments were not universally accepted, however, and strong opinions were expressed both for and against the new Expressionist techniques which had begun to replace the earlier naturalistic style of work. This can be seen as early as 1896 in *Bella's Illustrated Catalogue for the Posters Exhibition at the Royal Aquarium*, London. The debate became even more heated in 1917 when Roland Holst and Albert Hahn took part in a public discussion regarding the merits of the two approaches.

The two major centres for German poster production were Munich and Berlin. The film posters in the Central School collection were all commissioned by UFA and produced by the Berlin firm of Hollerbaum & Schmidt. Berlin did not have an art school tradition so poster production resulted from the demand for advertising from its many theatres, exhibitions and concert halls. A large number of printing businesses were established in Berlin during this period. Some were purely commercial in orientation and continued to produce posters in which a Plakat Kunstler produced an image to which text was later added. Others, however, had recognised the impact of the new approach of artists like the Beggarstaff Brothers and began to specialise in a more aesthetic approach to poster design. One of the best known of these was the Stieglitz Studio for whom Holwein designed during the early part of the century. This was established by

Fritz Hellmuth Ehmke and Friedrich Wilhelm Kleukens in 1900. It was essentially a workshop which concentrated on the production of high-quality artistic printed matter. One of the characteristics of the Stieglitz Studio was the quality of their lettering. The impact of their posters was not due just to the lettering used but also to the way in which it was integrated into the whole design. A number of the artists responsible for posters in the collection worked for the Stieglitz Studio, including Lucian Bernhard and Paul Scheurich.

Although UFA printed their own subtitles, pamphlets and descriptive literature they contracted out most of their poster work to Hollerbaum & Schmidt. It is likely they retained a high level of control over the type of design produced. The firm of Hollerbaum & Schmidt was one of the largest printing firms in Berlin during the 1920s. Although much of their archive has been lost, it is probable they followed a working practice similar to their contemporaries, Meissner & Buch Graphische Werke in Leipzig, who produced an annual sample book *Der Werbedruck: das Werkbuch der Firma Meissner & Buch*. This contained examples of the styles of work of their artists, together with discourses on various aspects of advertising and design. This enabled prospective clients to select the design to suit their requirements. Artists working for Hollerbaum & Schmidt at this time included Bernhard, Scheurich, Matejko, Wohlfahrt and Leonard. The poster designs produced for UFA cover a broad range of styles, reflecting the variety of films they produced. These included the light-hearted, folk style of *Kohlhiessels Töchter* by Leonard, the dramatically stylised work of Bernhard in *Veritas Vincit*, Wohlfahrt's beautifully integrated lettering and Expressionistic interpretation of *Der Reitende Tod*, and Scheurach's dramatic design of light and shade for *Anna Boleyn*.

Many of the publications on advertising and poster design included advice regarding materials. This can be seen in *Die Reklame* published by Paul Rubens in 1913 in which he advises not only on methods of advertising but also on the materials, such as the inks and paper, most suitable for posters. He also provided a list of recommended printers, which included Hollerbaum & Schmidt. The elaboration of new approaches to design also led to a search for new materials and the development of new technology. Machine-made papers sufficiently economical for ephemeral use had been available since the nineteenth century. However, it was not until the beginning of the twentieth that printing technology could take full advantage of the paper's width. The development of wider printing machines, together with the perfecting of offset lithographic techniques, enabled printers to produce long runs of large-format, high-quality posters quickly and economically. At the same time artists were able to use a broader range of brighter colours, many of which had been developed in the German dyestuffs industry.

The developments in poster design and the number of poster exhibitions led naturally to their becoming collectors' items. As a result, printers often held back some copies for sale to collectors. This is mentioned by Arsène Alexandre in *The Modern Poster*, 1895, and also by Bella in 1896. In 1908 Sachs had published *Die Plakatsammlung* which concentrated entirely on the housing and care of poster collections. Although there is little documentation relating to the acquisition of the German film posters by Central Saint Martins it seems likely that they were acquired in this way, especially in view of the fact that they have never been pasted up. The German film poster collection at Central Saint Martins College of Art and Design reflects exciting and critical developments in the design and film worlds during the 1920s. It must have played an important role in the study collection of an art school with a strong commitment to graphic art and design.

Timothy Clark

Nineteenth-century Japanese Actor Prints

After graduating from St John's College, Oxford, Timothy Clark continued his studies in Japanese Art History at Harvard University and in Japan, before joining the staff of the British Museum where he is now Assistant Keeper in the Department of Japanese Antiquities. He is the author of several catalogues of Japanese paintings and prints of the eighteenth and nineteenth centuries, the most recent being *The Passionate Art of Kitagawa Utamaro*, 1995 (with Shūgō Asano).

The Japanese colour woodblock prints of Kabuki actors in the Archive were all published in the middle decades of the nineteenth century in the cities of Edo (modern Tokyo) and Osaka. Within a few days of the opening of productions at the three government-licensed Kabuki theatres in Edo, print shops would be filled with displays of new colour prints showing leading actors in highlight scenes from the plays. The cost of each sheet was about twenty *mon*, the equivalent of a bowl of buckwheat noodles in a restaurant. A division of labour between artists, who supplied a simple brush-drawn design, and workshops of block-cutters and printers operating to the commission of competing publishers, meant that print production was carried out on an almost industrial scale.

Utagawa Kunisada (1786-1864), the leading designer of actor prints of his day, is credited with a total œuvre of perhaps 20,000 designs over fifty years, surely making him one of the most prolific graphic artists ever. Together with the dozens of pupils in his studio he produced several hundred designs a year, each issued in several thousand impressions (if they proved popular), and yet remarkably, despite this mass-production, very few designs are totally without compositional novelty. Each is, as a rule, carefully composed and – in the earliest impressions, at least – carefully printed.

The audience of buyers that sustained the colour print on such a high aesthetic and technical level was essentially the same as that for Kabuki itself: the merchants and artisans who constituted the so-called 'townsman' stratum at the bottom of the feudal hierarchy. This is not to say that Samurai, the top ten per cent of that hierarchy, did not go to the theatre or buy prints. But if they did so, then they were stepping out of their habitual world of privilege into the bustling, energetic world of 'downtown'. The theatrical form patronised by the Samurai was medieval Noh – understated, poetic, recherché. In contrast, Kabuki was typically brash, colourful, fast-moving and bursting with sentiment.

After its spread from the Kyoto-Osaka (Kansai) area to Edo in the later seventeenth century, Kabuki developed a regional split in styles maintained to this day. Kansai Kabuki was typical *wagoto*, 'soft-stuff', relishing the expression of subtle nuances of emotion, typically in 'domestic dramas' – contemporary tear-jerkers of love versus loyalty. Edo, a completely new city, initially with a somewhat frontier atmosphere, developed in contrast the *aragoto*, 'rough-stuff' style. *Aragoto* plays, the preserve of the Ichikawa lineage led by successive generations of actor-superstars who inherited the name Ichikawa Danjūrō, were populated by larger-than-life swashbuckling heroes wearing fantastic costumes. The plays tended to have historical or mythological plots involving warriors, monsters and deities. Although there was considerable mixing and development of these two broad traditions during the eighteenth century, even

Opposite
Utagawa Kuniyoshi, *Shimizu Sammounnosuke Seigen* (Japanese actor print), colour woodblock, 1832. 36 × 26 (15¼ × 10¼). Archive O.21

nineteenth-century actor prints can still illustrate this fundamental regional difference. Osaka had a much smaller school of printmakers who typically showed scenes from the domestic dramas or dance sequences with quick costume changes that were the forte of Kansai's leading actor Nakamura Utaemon III. The archetypal *aragoto* heroes of Edo, on the other hand, were the warrior brothers Soga no Gorō and Soga no Jūrō, who carried out a daring vendetta against their father's murderer, the villain Kudo Suketsune. The action is based on an actual historical incident when the brothers infiltrated the enemy hunting camp at night in the pouring rain and assassinated Kudo Suketsune in his tent. A play on some version of the Soga story was performed by tradition in each theatre at the New Year.

A kind of play popular in both regions, first developed for the rival puppet theatre (Bunraku) by the great Chikamatsu Monzaemon (1653-1724), was the love suicide. Choemon, middle-aged, married proprietor of a sash store, has an impossible affair with teenage O-han which ends with the pair throwing themselves into the Katsura River. A similar tragic end awaits the lovers Hanshichi, an employee of a sword shop, and O-hana, a courtesan. In plays written in the nineteenth century such plots become ever more lurid. Thus Yosaburō, handsome adopted son of a wealthy Edo family, falls for O-tomi, a geisha who is the mistress of a gangster, when the two meet on the beach at Kisarazu. When their affair is discovered, O-tomi throws herself into the sea, an apparent suicide, and Yosaburō is tortured and disfigured by the gangsters.

The role of Yosaburō was written in 1853 specifically for the superstar Ichikawa Danjūrō VIII, thirty years old, of ethereal good looks and at the height of his powers and popularity. Another highly successful role for him was Jiraiya, the chivalrous leader of a band of robbers. Danjūrō VIII's mysterious suicide in the eighth month, 1854, while on tour in Osaka, caused a sensation. The young man apparently took his life while, as we would now say, the balance of his mind was disturbed, but the precise reason has not been satisfactorily explained to this day. Rumours circulating at the time suggested resentment against the mistress taken by his father Danjūrō VII, after the death of Danjūrō VIII's mother. Literally hundreds of memorial prints were issued after the suicide. Normally in such prints an actor would be depicted kneeling in pale, religious robes holding a rosary, with his death poem printed above. One anonymous diptych to commemorate Danjūrō VIII, however, shows a throng of adoring female fans trying to rescue him from the clutches of a demon from hell. But even then the young actor was not allowed to rest in peace. In a play staged barely two months after his death, Danjūrō VIII was revived in a ghost role: a colour print triptych by Kunisada relating to this performance shows him painted on a hanging scroll as if he were a Buddhist guardian deity manifesting itself in a waterfall.

During the 1830s, perhaps under the influence of the new landscape prints of Hokusai and Hiroshige in which the design filled all corners of the page, there was a marked shift towards a more gaudy aesthetic in colour prints of all subjects. Gone are designs in which the actor stood elegantly silhouetted against an essentially plain background. The majority of the Central Saint Martins prints come from an album that contains works dating from the mid-1850s, many by Kunisada working at the peak of demand for his designs. Now the colours are saturated and boldly juxtaposed and there is a proliferation of cartouches giving series title, roles, artist's signature, etc. In the past critics have dismissed such prints out of hand as 'decadent' in comparison to the suave, balanced designs of the eighteenth century. But to do so entirely misses the point: Kunisada's actor prints directly reflect the up-front energy and confidence of a Kabuki that was vigorous, creative and still evolving.

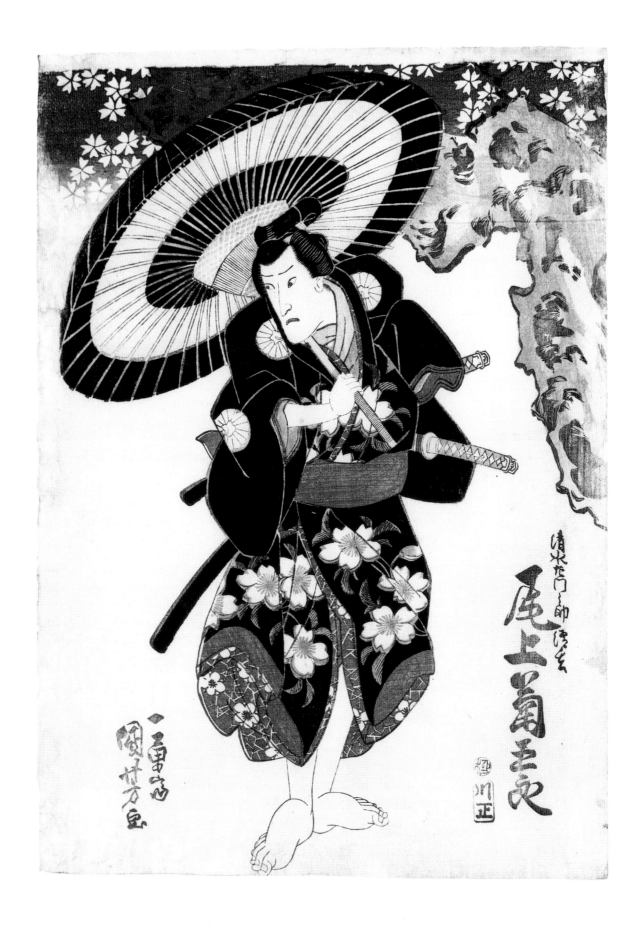

Mavis Pilbeam

Children's Games:
An Album of Japanese Woodblock Prints from the Middle of the Meiji Period (1868-1912)

Mavis Pilbeam first went to Japan in the early 1970s to teach English and study Japanese. She continued her studies at the School of Oriental and African Studies at London University, and later in Sheffield. Her interests are wide-ranging, and during her ten years as Education Officer for the Japanese Embassy in London she published two information books about Japan for children. In recent years, as Librarian for the British Museum's Department of Japanese Antiquities, she has been pursuing her long-standing interest in Japanese art.

In addition to its fine collection of Kabuki actor prints, the Art and Design Archive has a series of twelve woodblock prints, originally bound as a folding album, *Japanese Paintings: Children's Games* (*Kodomo no asobi gajō*), by the artist Kobayashi Eitaku (1843-90), here signing himself with one of his art names, Sensai. A frontispiece showing objects associated with the Seven Lucky Gods would suggest an intended publication date of New Year 1888, but the album actually appeared in June 1888. A Japanese Preface dated 17 September 1887, written by the Head of Hakubunsha publishing company, Nagao Kagesuke, and translated into English and French, is of particular interest for the light it throws on the motives behind the album's publication, which are, in turn, an indication of certain attitudes towards native arts in the 1880s.

Since the Meiji Restoration in 1868, traditional Japanese arts had come under considerable pressure from western techniques in painting and printmaking, and from photography. However, there was a reactionary swing in the late 1880s, with many people advocating a reappraisal of Japan's traditional arts. It is in this context that Nagao, moved by anxiety that something precious was about to be irretrievably lost, proposed his grand design. In his Preface, he maintains that the present deterioration has been caused by a tendency slavishly to imitate the ancient arts. Nagao's plan is to work closely with 'skilful artists', encouraging them, with 'the sympathy and help of native and foreign aesthetes', consciously to improve on the past: 'I shall endeavour not only to revive those fine arts which have been bequeathed to us by our ancestors, but to ensure their perpetuation by our descendants.' This modest album represents his 'first attempt' at controlling the relentless waves of change.

The production of woodblock prints required the collaboration of the 'ukiyo-e quartet' composed of artist/designer, engraver, printer and publisher. Since Nagao demanded an increase in the 'minuteness of the woodcuts' and 'still greater skill' in the printing, he must have selected his engraver, Kimura Tokutarō, and his printer, Tamura Tetsunosuke, with special care. The artist Kobayashi Eitaku completed the quartet. He was ideally qualified, with his traditional training in the official Kanō school of painting, his subsequent experience as a painter and print-designer in the style of the ukiyo-e (Floating World) school, and his practical experiments with elements of Chinese Ming and western painting.

A minor genre of prints of children developed in the Edo Period (1615-1868) alongside the more common themes of beautiful women, actor prints and landscapes. These sometimes took the form of *Mother and Child* prints, among the earliest known being works by Suzuki Harunobu from the 1760s. Then, as the children of the wealthier classes gradually attained some degree of independence from the adult world, developing their own 'culture of childhood', so artists' interest grew in depicting

children's games and festivals throughout the year, in print series which exclude adults entirely. An early example is the series *The Elegance of the Twelve Months* (*Furyū jūnigatsu*) by Ishikawa Toyomasa, *c*.1768. After him, most ukiyo-e artists produced prints of children in some form. Andō Hiroshige (1797-1858), famous for his landscapes, designed two large-scale sheets of *Boys' Games and Girls' Games* during the Tempō Era (1830-44), and both Kunisada and Kuniyoshi, whose actor prints figure prominently in this Archive, also treated the theme.

Most of the children portrayed are from the merchant families. For these children, in this period of peace and prosperity, the borders between work, education and play were clear-cut. They had leisure to play the new 'games with rules' which, often the invention of the lowlier artisans' and farmers' children, were one of the few things to cross the boundaries of class. The merchants' children also eagerly bought the specialised merchandise of toys and game-sets, the production of which their more sophisticated demands encouraged. Thus, with the formalisation, too, of many annual festival celebrations, the artists had a range of distinctive materials for prints of children.

In these prints, the boys generally display a cheerful energy, the girls a serene calm, though they, too, have their boisterous moments. Traditionally, young children have been the objects of affection and indulgence in Japan, often being referred to as *kodakara*, heaven-sent 'child-treasures'. People believed that a child's spirit might leave it, causing its death, at any time up to the age of seven, when it was finally anchored securely on earth with special ceremonies, the precursors of the *Shichi-go-san* (Seven-five-three) Festival. This is now celebrated annually on 15 November and blessings are called down on children aged three and five, as well as seven-year-olds. From the age of seven the sexes were brought up separately and more sober behaviour was encouraged. These attitudes and practices were common at every social level, and children could expect a happy early childhood.

With a few minor discrepancies, this series shows pastimes considered appropriate to each of the twelve months, just as in contemporary Japan certain patterns of daily life still follow the changing seasons.

1. January Battledore and shuttlecock game at New Year
2. February Spinning tops and blowing bubbles
3. March Board-games – backgammon and *musashi*
4. April Boys playing at Samurai warriors in the run-up to Boys' Day, 5 May
5. May Catching fireflies
6. June Fishing for goldfish
7. July A shrine festival
8. August The *O-Bon* Lantern Festival for the spirits of ancestors
9. September Shadow games
10. October Chasing rabbits and catching crickets
11. November Playing 'Thousand-armed Kannon' (*Senjū Kannon*)
12. December Snowman

The pastimes fall into three categories: Festivals (Nos 1, 4, 7, 8, possibly also 6 and 11); country games (Nos 5, 10 and 12); games using toys and game-sets (No.1 again, 2, 3 and 9).

On the whole, the sexes are segregated, though sometimes little brothers join in, in the care of older sisters. Since the kimono is worn by both sexes and hairstyles look remarkably similar, it is sometimes difficult to tell them apart. Sashes and footwear provide the clues, girls wearing the full *obi* (sash), wider than the boys' version with a more prominent and complex bow at the back. Boys always carry pouches at the waist.

On their feet girls wear high *zori* with a single toe-thong, while the boys' style is flatter. In *Snowman*, the boys wear high wooden *geta*. Their kimono are padded, and they tie their sleeves out of the way with cords as women would do for housework. This print is one of the most striking designs in the series, the dark green of the child's kimono contrasting with the white mass of the snowman. It is a *yukidaruma*, an effigy of Daruma, the founder of Zen Buddhism, with balls of charcoal for eyes, and it has a snow rabbit for company.

Another impressive print is *Catching Fireflies*, an unusual night scene. The carefully layered shading of the tree trunks and the dusky green of the leaves enhances the impression of darkness. Certain insects were popular: fireflies for their mysterious light, and crickets (lying abandoned in the *Rabbit chase*) for their song. Once caught, they were kept in tiny bamboo or gauze cages. Apart from the more familiar festival images of New Year and summer, Eitaku introduces a rare subject, children playing at *Senjū Kannon*. One child hoisted on another's back stretches out his arms to represent Kannon, a merciful deity extending his compassion to all mankind, while a third child pretends to pray to him. This could be an acting out of the *Shichi-go-san* Festival against a landscape background which uses strong western-style perspective with a subtly modulated sky. *Shadow Games* shows a beaming September harvest moon outside, while indoors a girl makes a shadow of the *Rabbit in the Moon* for her fascinated little brothers. Another group of children play with shadow-lanterns – the candle's heat rotates silhouette cut-outs representing the *Foxes' Wedding Procession*. (There was a saying that when sunshine and rain occurred together, somewhere a foxes' wedding was taking place. Here the slanting rain can be clearly seen.) A second lantern shows the Soga brothers hunting near Mount Fuji, another representation of this popular Japanese tale.

The design and attention to detail of these prints, the lifelike movement, and Eitaku's robustly endearing treatment of his child subjects, often in skilfully realised landscape settings, could not have failed to impress his audience. The meticulous care of the engraver, especially in carving the kimono designs, and of the printer dealing with up to eight colour blocks for each print, cannot be faulted. However, Nagao's scheme inevitably failed in its wider intention: although Japanese painting, known as Nihonga, flourishes to the present day, the 'ukiyo-e quartet' system of woodblock printing has largely died out, notwithstanding a self-conscious attempt at revival between 1915 and 1940. Most of the many woodblock artists active today cut their own blocks and claim membership of the larger international printmaking fraternity.

Kobayashi Eitaku, *Spinning Tops and Blowing Bubbles*, from the album *Children's Games*, colour woodblock, 1888. 41 × 30 (16¼ × 11¾). Archive O.48 (2)

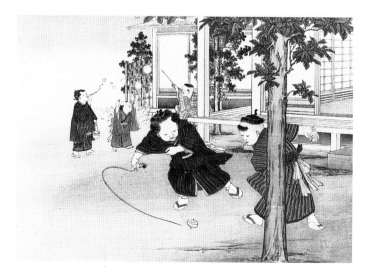

Noel Rooke, *A Central Granite Mountain Range*, LCC Schools Picture Collection, No.5, lithograph, 1919. 55.5 × 76 (22 × 30). Archive P.82.2a

L.C.C. School Pictures No.5 Central School of Arts and Crafts. A Central Granite Mountain Range. Noel Rooke

Robert Gibbings, *The Albert Bridge*, colour
woodcut, 1919. 18 × 12.3 (7½ × 5).
Archive P.1139.4

Top
John Farleigh, *Melancholia*, lithograph,
1936. 52 × 30 (20½ × 11¾). Archive P.959

Bottom
Blair Hughes-Stanton, *Night*, wood
engraving, 1975. 23.6 × 33 (9¼ × 13).
Archive P.1281

Top
Examples of nineteenth-century sign
lettering from The Central Lettering
Record

Bottom
German film poster for *Die Brüder
Karamasoff*, UFA, Berlin, 1920s. 69 × 95
(27$\frac{1}{4}$ × 37$\frac{1}{2}$). Archive POS.9.8

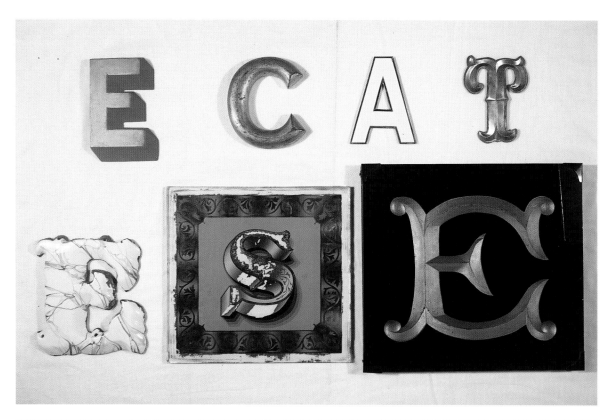

E. A. Bestall, *Howell's Annual Winter Sale*,
lithograph, 1923. 33 × 25.3 (13 × 10).
Archive P.996

HOWELL'S
ANNUAL
WINTER
SALE
JAN: 5TH—18TH

German film poster for *Veritas Vincit*, UFA,
Berlin, 1920s. 124 × 86 (49 × 34). Archive
POS.9.50

German film poster for *Anna Boleyn*, UFA,
Berlin, 1920s. 125 × 93.3 (49½ × 36¾).
Archive POS.9.26

Alex P. di Cesnola, *Salamini*, Whiting & Co.
Publishers, London, 1884.
Re-bound in the School of Book
Production. 26 × 17.5 (10¼ × 7)

Herbarium, Schoeffler Publishers, Mainz, 1484. Re-bound in the School of Book Production, *c.*1910. 23.2 × 16 (9¼ × 6¼). Archive B.494

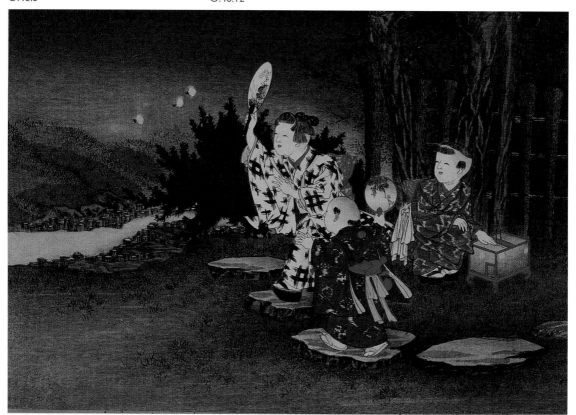

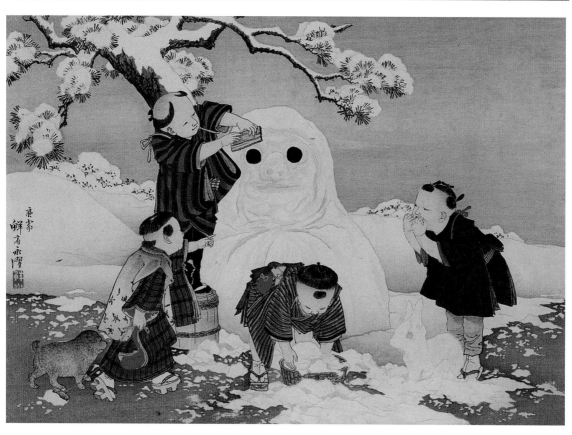

Yoshikuni Jukōdō, *Nakamura Utaemon III*
(Japanese Kabuki actor), colour wood-
block, c.1880. 38 × 25.5 (15 × 10). Archive
O.23

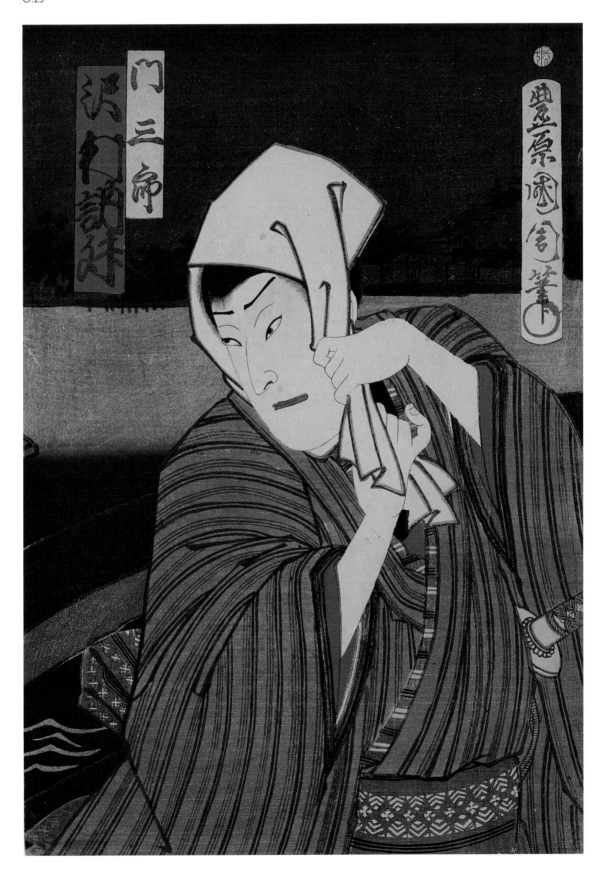

Paul Nash, *Big Abstract*, blockprinted
textile, 1925. Blocks cut by Joyce
Clissold. 80 × 69 ($31\frac{1}{2}$ × $27\frac{1}{4}$).
Archive T.I.1992.58 a+b

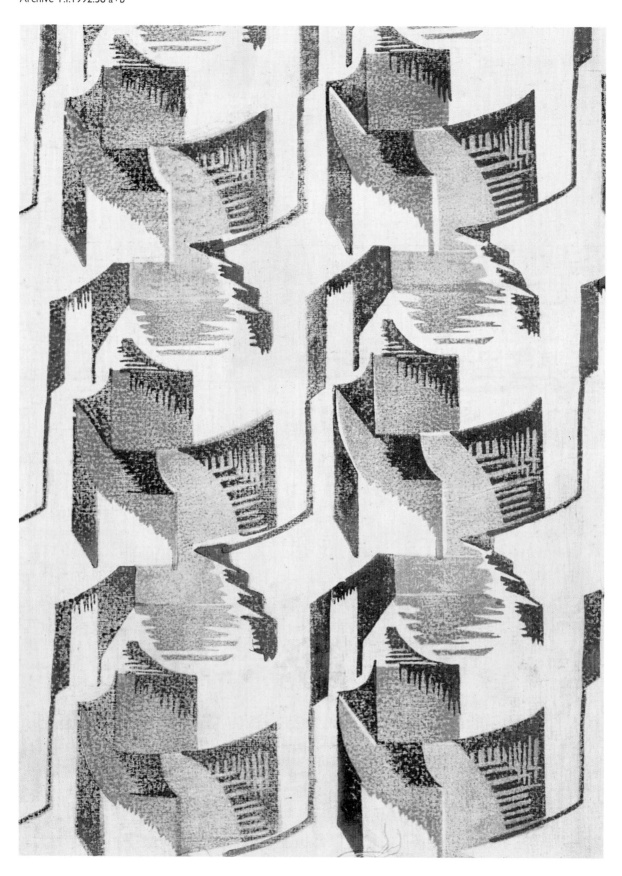

Doris Carter, *Theatre*, blockprinted textile
design, *c.*1928. Printed by Joyce Clissold at
Footprints. 27.4 × 98.5 (10¾ × 38¾).
Archive T.I.1992.4.a+b

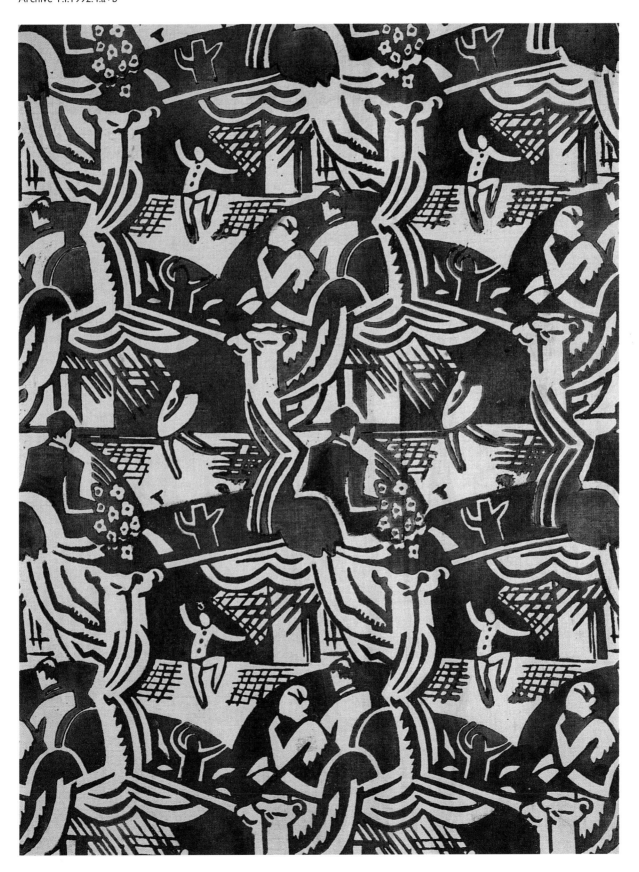

Joyce Clissold, *Beagles*, blockprinted
textile design for Footprints, *c.*1928.
45 × 48 (17¾ × 19). Archive T.I.1992.60.a-c

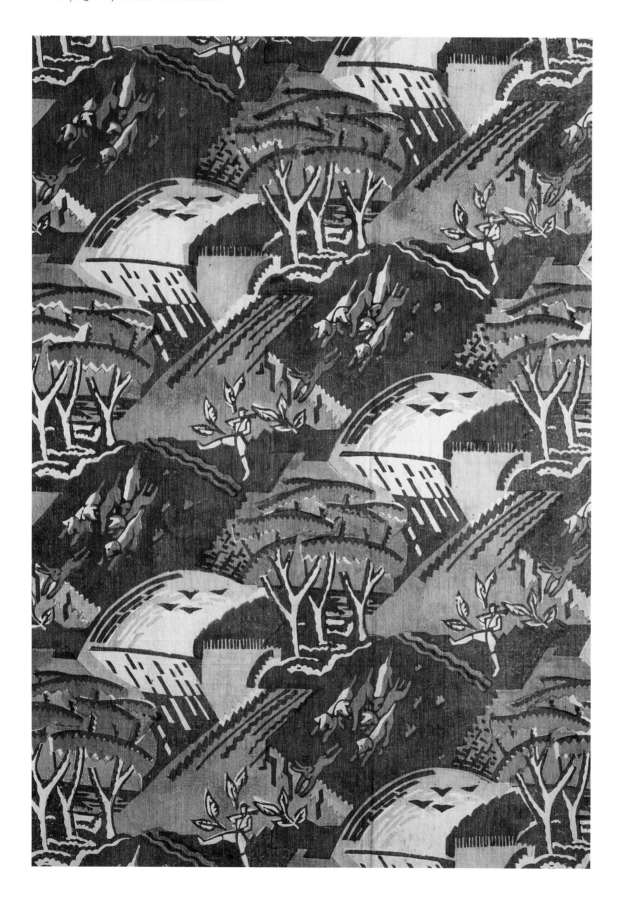

Mary Oliver, *London Square*, hand screen-
printed for Donald Bros, 1948. 6.9 × 12.5
(2¾ × 5)

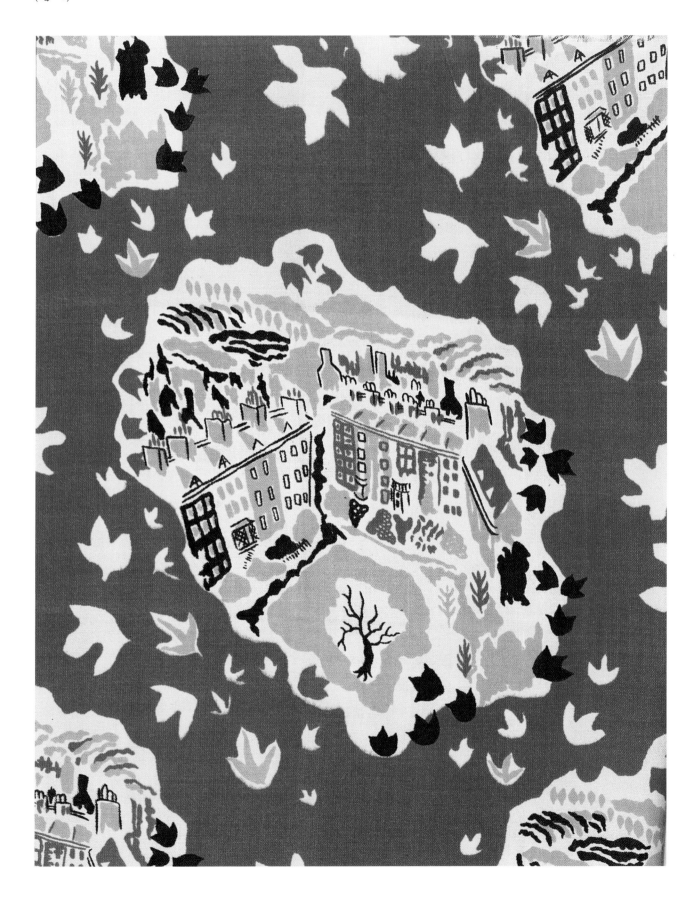

W. R. Lethaby, *Processional Way: sketch design for town planning showing a tree-lined boulevard leading from Waterloo Bridge to the British Museum,* pen and ink on paper, 1880s. 66.2 × 36 (26 × 14¼). Archive F.76

Mary Schoeser

Twentieth-century Textiles in the Design Archive

Mary Schoeser, a consultant archivist who specialises in textiles, has also curated a number of exhibitions, including *Bold Impressions*. Among her publications are *International Textile Design* (Lawrence King, 1995) and, as co-editor and contributor, *Disentangling Textiles: Interdisciplinary Techniques in the Study of Design* (Middlesex University Press, 1996).

Textiles have played an important role in shaping perceptions of the Central School since its inception. The impact of the Arts and Crafts movement can be seen in the development of the textile curriculum, which initially focused on embroidery, taught by May Morris from 1899 to 1908. Although the Archive contains no examples of student work from these years, among its volumes are May Morris's *Decorative Needlework*, as well as other books which indicate the continued importance given to craft-based teaching, including Ethel Mairet's *Hand Weaving and Education*, Mrs A. H. Christie's *Embroidery and Tapestry Weaving* and Luther Hooper's *Handloom Weaving*.[1] However, in terms of the more mass-produced or 'multiple one-offs' production, it was the Book Production Department, rather than the Textile Department itself, that had greatest impact on the printed textiles for which the College became known in the 1920s and early 1930s.[2] For this period the Archive holds an excellent collection of the work of Joyce Clissold and Footprints.

Clissold, a student from 1924 to 1927, studied wood engraving with Noel Rooke and design with Bernard Adeney, also spending time at Footprints, a block-printing workshop set up in 1925 to supply printed textiles for Elspeth Ann Little's shop, Modern Textiles. Little was herself a former student of the Central School's Book Production Department, and she, Gwen Pike (who initially ran the workshop) and Celandine Kennington (who funded it) were the founding trio; Paul Nash was also involved in the project, designing the shop's signboard and notepaper, advising on stock and designing four textiles. Nash was also familiar with the Central School (having taken evening classes there from 1908-10), and it is thought that he entrusted the block-cutting for three designs to Clissold. One of the most successful designs is probably *Theatre* by a Central School student, Doris Carter; there are several examples of her work in the collection of wood engravings. Clissold rejoined Footprints on the completion of her course and took over the workshop in 1929, creating all subsequent designs. In the 1930s she employed forty to fifty people and opened two Footprints shops in London; from 1936 to 1940 she also taught at the Central School. The workshop was maintained on a smaller scale after the war until her death in 1982, shortly after which her executors donated to the College a large Footprints' collection, together with their copyrights.

The Joyce Clissold Collection has provided the impetus for the study of Central School's printed textile designers since the 1920s. Initially, research focused on Footprints itself. The first task, to catalogue the collection (which consists of some 300 items, including textiles, garments, blocks, cutting tools, strike-offs, sketches, notebooks and a range of printed ephemera), was completed by 1993, shortly after which the *Joyce Clissold and Footprints* slide pack became available. Dr Hazel Clark, who provided the

introduction to this pack, had already used the collection as part of her research on modern textiles[3] and was shortly to publish a more detailed account of the retailing of block-printed fabrics and Footprints itself.[4]

As such projects progressed it became clear that Footprints represented an important example of an interwar phenomenon to which the Central School made a vital contribution, namely the development of a new approach to block-engraving that provided a direct link between art and industry. The implications of Rooke's revival of autographic and white-line engraving became the focus of *Bold Impressions: Block Printing 1910-1950*, which opened in the Lethaby Gallery in October 1995. It drew on the Joyce Clissold Collection, contextualising it by including fabrics, textile designs, prints and photographs from other collections, including work by other students of the Central such as Enid Marx, John Farleigh, Mary Oliver, Roy Passano and Diana Armfield, as well as their teachers, Noel Rooke, Bernard Adeney and Dora Batty, the latter two responsible for the transformation of the Textile Department in the early 1930s. The exhibition and its accompanying booklet also highlighted the importance of retail outlets, some of the most influential of which, like Modern Textiles and the Footprints shops, were also founded by former Central School Book Production students Margaret Pilkington (The Red Rose Guild, Manchester, 1921) and Dorothy Hutton (The Three Shields Gallery, London, 1922); also included were three fabrics by Central School students, commissioned in 1937 by Fortnum and Mason. At the same time, a conservation programme was put into place, using students from the Textile Conservation Centre at Hampton Court Palace to prepare objects for the exhibition, and also to conceive and create a system to protect small samples while allowing them to be consulted.

The management of the Joyce Clissold Collection not only contributed to academic research, the creation of a 'handling' collection for students and designers and the realisation of an exhibition, but also prompted further developments in a number of spheres. While on display at the College, the exhibition was supplemented by a conference (held in association with the Textile Society), at which one speaker argued that block-printed textiles of the 1920s and 1930s were 'a radical and unanswerable challenge to the dogma of modernism', a proposition later committed to print.[5] *Bold Impressions* was also the first Central Saint Martins College of Art and Design exhibition

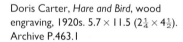

Doris Carter, *Hare and Bird*, wood engraving, 1920s. 5.7 × 11.5 (2¼ × 4½). Archive P.463.1

to travel, extending a glimpse of the Archive to exhibition-goers from Halifax to Truro. However, arguably the most rewarding result of the exhibition was the response of a number of visitors who were prompted to make further donations to the Archive.

Indirectly related to the Central School are a group of items representing the work of Phyllis Barron and, to a lesser extent, her partner from 1923 to 1953, Dorothy Larcher. Although neither attended the Central School, this collection gives an insight into Bernard Adeney's great familiarity with Barron's work. Barron and Larcher moved from London to Painswick in 1930 and

'Barron's first introduction to this part of the world had been some fourteen years earlier when London friends – Bernard Adeney and his first wife Terèse Lessore – had invited her to stay with them in their cottage in Tunley. . . A couple of years later Bernard met and subsequently remarried Barron's great friend the dress designer and painter, Noël Gilford, so the visits to Tunley continued.'[6]

Charlotte Forman, daughter of Gilford and Adeney, recalls as a child often wearing Barron's fabrics, and has donated a number of small samples, together with two blocks and a top, thought to have been printed and made up by Barron herself. These amplify the ability of the Archive to represent the stock of retail outlets such as The Red Rose Guild, The Three Shields Gallery and Modern Textiles – all of which sold Barron and Larcher fabrics – and is important comparative material for the Joyce Clissold Collection.

Adeney's impact on the second donor is recorded in the biography of Diana Armfield. Having studied briefly at the Central School just before World War Two, she returned to study textile design in 1945. She recalled Adeney as

'a cultivated man, a sensitive painter and a member of the London Group . . . He made us aware of "leading lines" and rhythms which take the eye beyond the edge of the motif, and also the need to set up implied movement. He led me to feel that my motifs of leaves and flowers were alive and needing as much consideration as the real thing.'[7]

Dora Batty also left an impression, particularly her exercises in abstract pattern-making:

'These exercises we carried out within the strict limitations of putting into repeat one-

Footprints tradecard, 1932. 6 × 10 ($2\frac{1}{2}$ × 4). Archive T.I.1992

Sheep, unbleached linen, blockprinted at
Footprints, with a design by Doris Scull,
late 1920s.
Archive T.I.1992.57

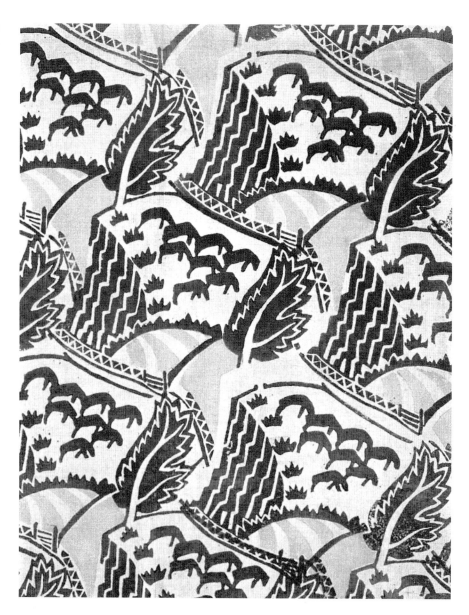

inch square linocuts. It amazed us that such restricted means could result in such
diverse and inventive solutions and that most were easily attributable to particular
students. Subsequently as a professional designer I included some of these patterns in
my portfolio, and they were taken up by wallpaper manufacturers, but I have also found
the principles on which they were based invaluable to me as a painter.'[8]

Thus the collection of textiles, designs, photographs, notes and order books donated by
Armfield give an invaluable insight into the teaching methods of Adeney and Batty, and
amplify Armfield's own approach to experiments with abstract elements and natural
forms.[9] They also document Armfield's wide range of work, representing her active
periods as a designer from 1949 to about 1952 (when she and fellow student Roy
Passano ran their own workshop and sold to private individuals, shops and the Council
of Industrial Design, the latter for the Festival of Britain) and again in the 1960s as a
freelance designer for companies such as Edinburgh Weavers, Coles, Lightbown

Aspinall, BCL Carpets, Shand Kydd, Hull Traders, Sanderson and Melody Mills (Wallpaper).

Mary Oliver, also a student of the Textile Department in the late 1940s, sustained her career as a designer from 1949 until the early 1990s. She, too, was taught by Dora Batty (as well as by Rooke, Bernard Meninsky and Mary Kirby among others) and in her subsequent work developed a reputation for striking, bright designs based on both abstract and natural forms. Among the firms she designed for were Edinburgh Weavers, Turnbull & Stockdale, and Heals, producing for the latter a half-tone print – based on Kew Gardens – that became a bestseller. She received commissions from the National Trust and formed a particularly fruitful working relationship with Donald Brothers, who issued her designs under a 'Mary Oliver Textiles' imprint. One of her earliest designs for Donald Brothers was *London Square*, which depicted the view from her flat whilst a student at the Central School and was included in the *Bold Impressions* exhibition.

A near contemporary of Armfield and Oliver was Mary Harper, whose husband, Robert Addington, is planning to make a considerable donation in her memory. He will be giving the substantial collection of slides his wife used in her teaching at the Central School. The Harper collection also includes twenty-five fabrics, many with colourways attached, most designed in the late 1950s and 1960s for Edinburgh Weavers and commissioned by Isabel Tisdall, with a few for Tamesa (established January 1964 by Isabel Tisdall). Addington recounts that the Edinburgh Weavers' design *Dahlia* went so well it eventually had to be withdrawn to make way for other designs. Harper's many designs for Edinburgh Weavers may well have resulted from her contact with Isabel's husband, Hans Tisdall, who joined the teaching staff at the School c.1948 (Armfield also recalls Tisdall, who 'opened our eyes to the interaction of one colour against another, not in theory but in practice').[10] Among the handful of earlier works are fabrics produced by Gayonnes and one Cole wallpaper, as well as hand-prints by Harper, using blocks probably cut at the Central School under Batty, but possibly printed up later. Included with the collection are press-cuttings and advertisements, which will provide future researchers with ready access to evidence regarding the marketing of Harper's designs. Other elements of the collection demonstrate an interest in a wide range of textiles, including Swedish and Finnish printed textiles obtained by John Drummond (another Central School textile student who went to Finland and became friendly with Timo Sapaneva)[11] and the only block print available commercially in the 1970s – from Liberty.

In a short space of time, the activity generated by the Joyce Clissold Collection greatly increased the Archive's holdings and its ability to act as a creative 'spark' for further research and design developments. Already identified is the ambition to obtain examples to represent the numerous other students and staff whose work was of influence and is not yet represented in the Archive, including that of Enid Marx, Gordon Crook, Hans Tisdall, John Drummond, Audrey Levey, Eduardo Paolozzi, Terence Conran, Peter Collingwood, Colleen Farr, Hugh Mackinnon and Althea NcNish.

1. Luther Hooper was teaching weaving at the Central School in 1920.

2. Lindsay Butterfield taught textile design from 1918 to 1934; from 1931 to 1940 the School of Textiles was run by Bernard Adeney, who had joined the Central School in 1905 and ran the School of Drawing and Design from 1908 to 1931.

3. Hazel Clark, 'Modern Textiles 1926-39', *Journal of the Decorative Arts Society*, No.50, 1991, pp.18-24.

4. Hazel Clark, 'Selling Design and Craft' and 'Footprints', *Women Designing*, University of Brighton, 1994, pp.61-3 and 82-7.

5. Alan Powers, 'Blocked Out?', *Crafts*, No.139, March/April 1996, pp.34-7.

6. Barley Roscoe, 'Phyllis Barron and Dorothy Larcher', *The Arts and Crafts Movement in the Cotswolds*, Alan Sutton, 1993, p.125.

7. Julian Halsby, *The Art of Diana Armfield*, David and Charles, 1995, p.24.

8. ibid.

9. Diana Armfield, 'An introduction to Designing Wallpapers and Fabrics: Part II and Part III', *The Artist*, Nos 2 and 3, Vols 71 and 72, pp.32-4 and 56-8.

10. Armfield, op.cit.

11. Sapaneva taught textiles at the Helsinki Institute of Industrial Arts and is best known for glass, but designed textiles, especially for Tampala.

Godfrey Rubens

The Drawings of William Richard Lethaby

Godfrey Rubens is a painter and designer
and architectural historian. He is the
author of *William Richard Lethaby: His Life
and Work*, and is currently editing a
collection of Lethaby's essays on
architecture and design.

William Lethaby's drawings fall into distinct groups, the first and largest being working
drawings and designs for artefacts; second, museum and topographical studies; and
finally, some fanciful illustrations and landscapes executed in watercolour.

As a small boy his interest in drawing was awakened by the cut-out cardboard animals
made by an artist friend of his father and led, when he was eleven, to his attending the
evening drawing classes organised by the Government Department of Science and Art
at Barnstaple's Literary and Scientific Institute. This class had limited aims and consisted
of copying drawings of simple geometrical shapes, examples of historic ornament and
drawing from casts of a similar nature. In a decade or so of attendance at the Institute
he won prizes for art, geometry, mathematics and building construction. Independently
he studied the reproductions in the architectural journals.

At about fourteen he was apprenticed to Alexander Lauder, a local architect and
competent draughtsman and modeller. Lauder was the designer of a number of Gothic
Revival chapels and a perspective of one of these is among Lethaby's first published
drawings. He was a disciple of Ruskin and by some accounts a dedicated teacher who,
no doubt, encouraged young William to draw directly from nature and probably to
study Ruskin's *Elements of Drawing*.

To promote the quality of design, *The Building News* started a Designing Club and
organised a monthly competition, judged by the architect Maurice Adams, that ran
throughout 1878, participants being asked to design a wide variety of subjects: buildings,
architectural details, furniture and household items. Lethaby, using the pseudonym
'Début', submitted nineteen designs which Adams described at first as 'effective but
scratchy', but finally as 'usually marked not only by considerable refinement as well as
feeling, but by some originality'. The work, for which Lethaby was awarded the first
prize, is in a variety of Gothic and Classical styles with the latter predominating in later
designs. They evince a surprisingly wide knowledge of the art of the past with more than
a hint of early nineteenth-century French design and of Karl Schinkel. Generally the
planning is straightforward except where some, probably unconscious, symbolic element
is present: the chilling design for a funeral chapel was criticised as having a 'deathlike
serenity' and not 'sufficiently suggestive of a Christian burial'. Another for a small villa in
the Queen Anne style had a cruciform plan and was thought by Adams to be 'too
piquant'. Impractical it certainly was, showing that the designer was prepared to sacrifice
service for Christian symbol. In an attempt to render sensible the transcendental, the
precursor of a later passion, Lethaby had attempted to marry the expressive to the
symbolic.

More attractive, 'ingenious, picturesque and suggestive' was the clever design for a
mountain chapel. These designs bring together all that he had learned in Barnstaple,

Side Elevation "Building News" Designing Club ~ End Elevation ~

A Cemetery Chapel

DÉBVT

1

W C

Organ Vestry

Corpse

Porch Waiting Rm

Seats

Ground Plan Section

W. R. Lethaby, Design for a cemetery chapel, ink on paper 1877. 49.5 × 32.5 (19$\frac{1}{2}$ × 12$\frac{3}{4}$). Archive F.I.1993.3

show a wide interest and knowledge of contemporary trends in design, and are important, too, as a probably unique collection reflecting the work of a young architectural assistant, albeit a precocious one, in the 1870s. His virtuosity was shown again in successful designs for two RIBA competitions, the Soane Medallion and the Pugin Memorial Travelling Scholarship in 1879 and 1881. The latter was won in part with a museum study of a mid-sixteenth-century Flemish tomb, but nobody, it seems, found any irony in this. With the prize money he travelled in the west of England: the Soane, on the other hand, paid for walking tours through Normandy and the Loire valley when he made many superb topographical studies.[1] This prize had been won with a design for a 'Building to accommodate Four Learned Societies' on a site on the Thames Embankment: it was judged 'a clever piece of work exhibiting considerable power and artistic feeling'. The 'chief intention,' wrote Lethaby of the design in a restrained French Renaissance manner, 'was to do without an order, and to obtain some originality without the eccentricities of later developments.'

A year or so later, Norman Shaw, after showing one of Lethaby's drawings to his staff, told them he was going to ask him to become his new chief clerk. At that time Shaw, who was working on the designs for Bedford Park, Turnham Green, London's first garden suburb, was employing Adams. It is likely that this drawing, perhaps a Début drawing, or one influenced by Shaw's style that he had published in the architectural press, came from Adams. Lethaby, who was then twenty-two, rapidly took charge of the office and from the first was quite prepared to do anything from eight-scale sections to full-size drawings of ornament or perspectives in ink or colour. Almost immediately he

W. R. Lethaby, Fireplace design, ink and watercolour on tracing paper, undated, 33 × 16.2 (13 × 6½). Archive F.67

Opposite
W. R. Lethaby, *Entrance to the Chrystotriclinium, Imperial Palace, Constantinople*, pencil, 1889. 60 × 43 (24 × 17). Archive F.66

seems to have been given a free hand to design the details of Shaw's buildings: an assured but conventional detail for the billiard-room stair for Fleet in Devonshire must be one of the earliest.[2] His drawing quickly matured, becoming free and, more apparent than real, loose in comparison with that in vogue in the office. The compromise between his own freer draughtsmanship, which is never precious, and Shaw's more precise manner is exemplified in the drawings for Dawpool built for Thomas Ismay in 1882-6, specially prepared for the Royal Academy Summer Exhibition in 1884, and in the later designs for his own buildings.

Shaw insisted that he, like all his clerks, attend the Royal Academy Architectural School, which despite its grandiose title, offered no more than evening classes in design and was taught, at that time, by Phène Spiers, G. E. Street, Shaw and Alfred Waterhouse. Several of Lethaby's school drawings[3] survive, each in the architectural style of his immediate teacher. Lethaby recalled without irony, 'It was good fun but it was anarchy.'

Later designs were sometimes eclectic, such as the font and cover for Shaw's church of St John the Baptist in Low Bentham, Lancaster (1889), whose form owes much to the fifteenth-century illustrations in the *Hypnerotomachia Poliphili*. More adventurous and exotic is the body of work, mostly competition designs, produced outside office hours. First comes the wild Anglo-Flemish confection of the unsuccessful design of St Anne's School, Streatham (1882). Between 1882 and 1884 he produced prize-winning designs, which do not appear to have been executed, for silverware for the Goldsmith Hall competitions. These, although in the same style, are far more restrained. One, a centrepiece for flowers, may have influenced the silver work of Lethaby's friend Henry Wilson. From the mid-1880s he made designs for several ironmasters for cast-iron fire-grates decorated with tiny flutings, beads and leaf mouldings, sometimes with little figure medallions.

In 1884 he received the commission for a stained-glass window depicting the Four Evangelists, for the church of St John the Baptist in Symondsbury, Dorset,[4] whose complex iconography originates in Mrs Jameson's *Sacred and Legendary Art*. The cartoons of the Evangelists represent his only known large-scale figure drawings.

The Entrance to the Chrysotriclinium illustrates Pausanias' description of part of Constantine's palace in Constantinople and is one of several drawings associated with Lethaby's first book, *Architecture, Mysticism and Myth*. Another, *The Beryl Shrine*, the strange and disturbing illustration to Dante Gabriel Rossetti's poem 'Rose Mary', manifests a recondite and personal symbolism.

To this period belongs the drawing *A Proposal for a Sacred Way*, which would have joined the British Museum to Waterloo Bridge by a wide tree-lined pedestrian concourse and is the first of many innovative proposals for the rebuilding of London.

It was a time of continual experiment and the incorporation of many and diverse influences from that of William Burges to ancient Greece, the latter manifested in a design for the decoration of a *Room in panelling and paint*,[5] exhibited at the first Arts and Crafts exhibition in 1889.

The Collection's furniture designs include some for the short-lived furniture-making cooperative Kenton & Co set up with Sidney Barnsley, Ernest Gimson, Reginald Blomfield and Mervyn Macartney. There are sketches for a dresser for Ernest Newton's Buller's Wood, and tables for Stanmore Hall and Avon Tyrrell. This work, devoid of historical reference, is rectilinear with chevron or semi-abstract inlays (sideboard for the Melsetter house) and expresses the designer's final abandonment of eclecticism. Furnishing and building journals did not like the work: 'The new school of designers appear to be losing the sense of style, and the dignity of design which accompanies it altogether. The object now seems to be to make a thing as square, as plain, as devoid of

1. Annotated sketch book, RIBA Drawings Collection, which holds a very large collection of Lethaby's sketch books.

2. Royal Academy Drawings Collection.

3. Formerly owned by the late A. B. Waters.

4. Victoria and Albert Museum.

5. A. B. Waters.

6. *The Builder*, 1899, p.335.

7. First published in *Plain Handicrafts* (1892), republished as *Simple Furniture,* Dryad Leaflet No.5 (*c.*1920) and in 1984.

8. RIBA Drawings Collection.

9. Arthur Keen, *RIBA Journal,* Vol.39, p.411.

10. Victoria and Albert, Tate Gallery, Central Saint Martins Archive.

11. *RIBA Journal,* Vol.38, p.737.

any beauty of line as is possible and call this art.'[6] Nevertheless it sold well, for, liked by the avant-garde, it embodied still-accepted ideas of furniture design which Lethaby had set out in *Cabinet Making*.[7]

A very large collection of his sketch books survives,[8] the source of many illustrations in his books and articles, which witness to his sharp-eyed, imaginative draughtsmanship and concern to convey the appearance of things. To see Lethaby at 'work in a museum was to receive a useful lesson in close and exhaustive analysis. His power of observation is illustrated in everything he wrote, and he seemed able to refer confidently to things seen years before, although studied at the time from quite a different standpoint.'[9]

The topographical studies, the majority of French cathedrals made partly on two Soane tours in 1881 and 1882, are splendid examples of the genre: close observation allied to sparkling pencil work and a great understanding of form in sculpture. The landscapes[10] and the studies of much-loved trees done for his own amusement and unknown until his death are freer and executed with greater verve.

Something of his way of working is captured in Alfred Powell's description of a sketching trip. 'He caught hold of my drawing and said, "Alfred, you don't know how to do it; you want to get lather into it" and he picked up a bunch of grass, and rubbing it over the drawing, produced a wonderful texture.'[11]

W. R. Lethaby, Scheme for Kingsway (unexecuted), charcoal and pencil, *c.*1900. 50 × 31 (19¾ × 12½). Archive F.56

Bibliography Stuart Evans

History of Central School of Arts and Crafts and Central Saint Martins College of Art and Design

Sylvia Backemeyer and Theresa Gronberg (eds), *W. R. Lethaby (1857-1931) Architecture, Design and Education*, Lund Humphries, 1984.
>See in particular Gronberg's 'W. R. Lethaby and the Central School of Arts and Crafts', pp.14-23.

Sylvia Backemeyer and Theresa Gronberg, *Central Saint Martins: Founding Histories*, The London Institute, 1990.

Sylvia Backemeyer, 'Archives and collections: Central Saint Martins Art and Design Archive', *Journal of Design History*, 1992, vol.5, No.4, pp.295-300.

Godfrey Rubens, *William Richard Lethaby: His Life and Work, 1857-1931*, Architectural Press, 1986.
>See in particular 'Work for the London County Council', pp.175-98, on the Central School of Arts and Crafts.

Central School staff and students

Patience Empson, *The Wood Engravings of Robert Gibbings*, J. M. Dent, 1959.

Julian Halsby, *The Art of Diana Armfield*, David and Charles, 1995.

James Hamilton and W. Condry, *Wood Engraving of Gertrude Hermes*, Gregynog Press, 1988.

James Hamilton, *Wood Engraving and the Woodcut in Britain c.1890-1990*, Barrie and Jenkins, 1994.

Justin Howes, *Edward Johnston (Introduction to the Pioneers of the Twentieth Century in Graphic Design)*, Lund Humphries, 1996.

Penelope Hughes-Stanton, *The Wood Engravings of Blair Hughes-Stanton*, Pinner: Private Libraries Association, 1991.

Patricia Jaffe, *Women Engravers*, Virago, 1988.

Priscilla Johnson, *Edward Johnston*, Faber and Faber, 1959.

Fiona MacCarthy, *Eric Gill*, Faber and Faber, 1989.

Leslie Owens, *J. H. Mason, 1875-1951, Scholar Printer*, Muller, 1976.

Monica Poole, *The Wood Engravings of John Farleigh*, Gresham Books, 1985.

Jill Seddon and Suzette Worden (eds), *Women Designing: Redefining Design in Britain between the Wars*, University of Brighton, 1994.

John Russell Taylor, *Bernard Meninsky*, Redcliffe, 1990.

History of art and design education and institutions

Alan Crawford (ed.), *By Hammer and Hand: The Arts and Crafts Movement in Birmingham*, exhibition catalogue, Birmingham Museums and Art Gallery, 1984.
>See in particular 'The Birmingham setting: a curious mixture of bourgeoisie and romance'.

Hugh Ferguson, *Glasgow School of Art: The History*, The Foulis Press of Glasgow School of Art, 1995.

Christopher Frayling, *The Royal College of Art: One Hundred and Fifty Years of Art and Design*, Barrie and Jenkins, 1987.

David Jeremiah, *A Hundred Years and More*, Manchester Polytechnic, 1980.

David Jeremiah, 'The culture and style of British art school buildings: part 1. The Victorian and Edwardian legacy', *Point: Art and Design Research Journal*, 1995, 1, pp.34-47.

David Warren Piper (ed.), *Readings in Art and Design Education: 1: After Hornsey*, Davis-Poynter, 1973.

David Warren Piper (ed.), *Readings in Art and Design Education: 2: After Coldstream*, Davis-Poynter, 1973.

Godfrey Rubens, *William Richard Lethaby: His Life and Work, 1857-1931*, Architectural Press, 1986.
See in particular 'Work for the London County Council', pp.175-98, on the Central School of Arts and Crafts.

Mary Schoeser, *Bold Impressions: Block-printed Textiles 1910 to 1950*, Central Saint Martins College of Art and Design, 1995.

Jonathan M. Woodham and Suzette Worden, *From Art School to Polytechnic: Serving Industry and the Community from Brighton, 1859-1986*, Faculty of Art and Design, Brighton Polytechnic, 1986.

Texts of and on the period

Walter Crane, *The Bases of Design*, George Bell and Sons, 1898.

Walter Crane, *Line and Form*, George Bell and Sons, 1900.

W. R. Lethaby (ed.), *The Artistic Crafts Series of Technical Handbooks*, John Hogg. Volumes from this turn-of-the-century series were written by Central School staff, unsurprisingly as Lethaby was its editor. They capture the School's spirit in addressing students as well as practitioners and emphasising design as much as making skills. The Series began publication in 1903. Many went through several editions and were published latterly by Sir Isaac Pitman & Sons. Examples are:

Mrs Archibald H. Christie, *Embroidery and Tapestry Weaving*.

Douglas Cockerell, *Bookbindings and the Care of Books: A Textbook for Bookbinders and Librarians*.

Luther Hooper, *Hand-loom Weaving*.

W. H. St John Hope, *Heraldry for Craftsmen and Designers*.

Talbot Hughes, *Dress Design*.

George Jack, *Wood Carving, Design and Workmanship*.

Edward Johnston, *Writing and Illuminating, and Lettering*.

C. W. Whall, *Stained-glass Work*.

H. Wilson, *Silverwork and Jewellery, a Text Book for Students and Workers in Metal*.

Roger Manvell, *Masterworks of the German Cinema*. Dent, 1973.

Gillian Naylor, *The Arts and Crafts Movement: A Study of its Sources, Ideals and Influence on Design Theory*, Studio Vista, 1971.

Nikolaus Pevsner, *Studies in Art, Architecture and Design: vol. 2, Victorian and After*, Thames and Hudson, 1972.

Julius Posener, *From Schinkel to the Bauhaus: Five Lectures on the Growth of Modern German Architecture (Architectural Association Paper No.5)*, Lund Humphries, 1972.

Mark Swenarton, *Artisans and Architects: the Ruskinian Tradition in Architectural Thought*, Macmillan Press, 1989.

Gleeson White (ed.), *Practical Designing: Handbook on the Preparation of Working Drawings*, George Bell and Sons, 1894.

Biographies of Some Central School Staff and Students Mentioned in This Book

Norman Ackroyd (b.1938)
Born in Leeds, he studied at Leeds College of Art and the Royal College of Art, London. Taught at the Central School from 1965 to 1994 and at the Royal Academy Schools. He is probably best known for his etchings of British landscapes, all of which are suffused with the 'Spirit of Place'. He also works in watercolour. Some of his prints are in the form of Artists Books.

Dora Batty (1900-66)
Dora Batty was an artist and designer who worked in various media. She was a designer of posters, particularly for the London Underground, for whom she produced over sixty, and did advertising work for MacFisheries. As a textile designer she worked for companies such as Barlow & Jones and Helios with work sold at specialist design outlets like Heal's and Dunn's of Bromley. As a ceramic designer she worked for Poole Pottery. She was also an illustrator and her work was included in the *Britain Can Make It* exhibition, 1946. From 1932 to 1958 she was a tutor in textiles at Central School, latterly as Head of Textiles. Past students recalled the innovative teaching there. She was instrumental in bringing Marianne Straub to join the Central School's staff as a part-time instructor of weaving.

Nicholas Biddulph (b.1926)
Co-founder of the Central Lettering Record with Nicolete Gray, Biddulph studied fine art at the Slade School of Art, London, after his army service in the Middle East had sparked an interest in the ancient civilisations of Egypt, Greece and Rome. His studies were followed by a year in Rome, working at the Vatican and other museums. It was here that he developed a special interest in Roman lettering which led to a career in advertising and design when he returned to England. Biddulph was appointed to the Central School of Arts and Crafts after a period of lecturing at London University and at art and design colleges in England. In addition to teaching, he travelled widely as a photographer, producing detailed studies of architectural lettering, and museum holdings of books, types and lettering, which entered the Record. Throughout his career he designed and produced numerous exhibitions and contributed articles to specialist journals. He retired in 1991.

Douglas B. Cockerell (1870-1945)
Cockerell started his bookbinding career as T. J. Cobden-Sanderson's first apprentice in 1893. He taught bookbinding at the Central School from 1897 to 1904, continuing as a visitor until his retirement in 1935. He had his own bindery and was in charge of W. H. Smith's bindery from 1904 to 1914. Elected to the Art Workers' Guild in 1896, Cockerell was designated Royal Designer for Industry. His most famous binding is probably the *Codex Sinaiticus* undertaken for the British Museum between the wars.

John Farleigh (1900-65)
Farleigh was apprenticed in 1914 to the Art Illustrators agency. He attended evening classes in life drawing for ten years at the Bolt Court School. He was a pupil of Rooke who introduced him to wood engraving and of Bernard Meninsky at the Central School from 1919 to 1922. After two years' teaching art at Rugby School he returned to the School where he taught from 1925 to 1948. Farleigh was an outstanding book illustrator, working mainly as a wood engraver. He made his name with the illustrations to Bernard Shaw's *The Adventures of the Black Girl in Her Search for God* (Constable, 1932). Farleigh wrote on the crafts himself. His best known book is *Graven Image* (Macmillan, 1940).

Frank Morley Fletcher (1866-1949)

While teaching at the Central School from 1897 to 1904, Fletcher introduced the art of wood engraving in colour, using Japanese techniques. He was elected to the Art Workers' Guild in 1914. Fletcher wrote extensively on art and art education. In 1916 he published *Wood-block Printing*, one of the Artistic Crafts Series edited by Lethaby. He had a distinguished career in teaching art and as well as teaching at the Central School, he taught at University College, Reading, Edinburgh College of Art, and The School of Art, Community Arts Association, Santa Barbara, California.

Robert Gibbings (1889-1958)

Gibbings studied at the Slade School of Fine Art and as an evening class pupil of Noel Rooke at the Central School where he learned to use the 'white line' style of wood engraving. He also studied typesetting and received a good grounding for his later work in the private press movement. He lectured in book production at Reading University from 1939 to 1942. Gibbings founded the Society of Wood Engravers in 1919 and became the owner of the Golden Cockerel Press in 1924. He decorated many of their publications himself as well as illustrating many other books with his wood engravings.

Nicolete Gray (b.1910)

Nicolete Gray's particular contribution to the Central School is the Central Lettering Record which she helped Nick Biddulph to establish and which is described here in Eric Kindel's essay. A more general contribution was in the teaching of a course on lettering (she trained as a palaeographer) for the graphic design students. This was an innovation in the 1950s at a time when, under the impact of new technologies, lettering was increasingly neglected, even at the Central School with the Edward Johnston connection. Her influence on generations of designers has been extended through her books *Nineteenth Century Ornamented Types and Title Pages*, first published in 1938, and *Lettering on Buildings*, 1960.

A. S. Hartrick (1864-1950)

Born in India, Hartrick studied at the Slade School of Fine Art and the Académie Julien. While in Paris he became a friend of Gauguin, Van Gogh and Toulouse Lautrec. He taught at Camberwell School of Art and from 1914 at the Central School. Hartrick worked as a book illustrator and watercolourist and did work for many magazines including *The Graphic*. He was a founder member of the Chelsea Arts Club and Vice-President of the Senefelder Club.

Gertrude Hermes (1901-83)

Gertrude Hermes worked as a wood engraver, stained glass designer and sculptor. She studied art at Beckenham School of Art and the Leon Underwood School of Painting and Sculpture where she met Blair Hughes-Stanton. They married in 1926 and their early work showed strong similarities in style. They worked at the Gregynog Press together. From 1945 Hermes taught wood engraving at St Martins School of Art, Camberwell School of Art and the Central School of Art and Crafts where she taught until 1966.

Blair Hughes-Stanton (1902-81)

In the renaissance of wood engraving Blair Hughes-Stanton stands out as significant both for his printed work and for his inspiration as a teacher. Born into an artistic family, he trained in London at the Byam Shaw School and then at Leon Underwood's School of

Painting and Sculpture where he learned wood engraving which he explored in the late 1920s. In 1930 he started work at the Gregynog Press, returning in 1933 to London where he established his own Gemini Press. In the 1950s he enjoyed a fruitful period of collaboration with the Allen Press in California. From 1952 Hughes-Stanton taught at the Central School. He retired aged 77.

Edward Johnston (1872-1944)

Born in Uruguay, Johnston originally studied medicine in his native Scotland. Under the influence of Lethaby he took up the art of calligraphy and lettering and taught writing, illumination and lettering at the Central School from 1899. His pupils included Rooke, Gill and Mason. His seminal book *Writing and Illuminating and Lettering*, one of the Artistic Crafts Series, was published in 1906. He was elected to the Art Workers' Guild in 1901. Johnston undertook designs for the Doves and the Cranach Presses and did the designs for the London Transport lettering in 1916 to 1918, some of which are still in use.

Lynton Lamb (1907-77)

Born in India, Lamb studied under Meninsky, Hartrick and Rooke at the Central School from 1927 to 1930. He worked as a wood engraver, painter, designer and illustrator. He also studied bookbinding under Cockerell and taught this part-time during the 1930s. He was appointed a Royal Designer for Industry in 1974. After World War Two Lamb worked mainly in pen and ink and lithography, drawing directly onto paper or plate without preparatory sketches.

W. R. Lethaby (1857-1931)

Born in Barnstaple, Devon, Lethaby was apprenticed to Alexander Lauder and later became chief clerk to Norman Shaw. He had a brilliant career as an architect before turning to education. Appointed founding Principal of the Central School of Arts and Crafts in 1896 Lethaby was appointed first Professor of Design and Ornament at the Royal College of Art in 1905. He continued to run the Central School until 1910. Lethaby wrote extensively in the field of art and design education and architecture. He was elected Master of the Art Workers' Guild in 1911. From 1906 to 1927 Lethaby was Surveyor to the Fabric of Westminster Abbey and succeeded in preserving much that otherwise would have been demolished.

John H. Mason (1875-1951)

A master printer and self-taught classical scholar, Mason began his career as a proof-reader at Ballantynes in 1888. He was an extremely skilled compositor and worked his way up, joining the Doves Press in 1900. He taught at the Central School from 1905 where he was responsible for developing the Day Technical School for Printers and initiating the high standard of workmanship for which the Central School of Book Production became known. He was designated a Royal Designer for Industry in 1938.

Bernard Meninsky (1891-1950)

Born in the Ukraine, Meninsky came with his family to Liverpool as a baby. He attended Liverpool School of Art, the Royal College of Art and the Académie Julien in Paris. In 1912 he won a scholarship to the Slade School of Art and in 1913 began teaching at the Central School where he taught drawing and painting until 1940 and influenced many students. Meninsky suffered from mental illness for much of his life, finally committing suicide in 1950. His obituary described his work as a 'blazing talent of rare visionary power'.

May Morris (1862-1938)

May Morris trained at the National Art Training School (later the RCA), specialising in embroidery. She exhibited regularly and her work was included in the first Arts and Crafts Exhibition Society show at the New Gallery in 1888. Her reputation as an embroiderer continued to develop through to the 1920s. In the early days of Central School she established courses in Embroidery and Textiles, which continued to be run 'under her direction'. She had a wider influence as one of the leading women craftworkers and in 1907 she founded the Women's Guild of Art. Outside the crafts she also had a significant role as a writer, in the socialist movement, and in assisting her father, William Morris, whose literary work she edited.

Noel Rooke (1881-1952)

Son of the artist T. M. Rooke, Noel Rooke was educated in France. He studied at the Central School under Lethaby and Johnston. Rooke was responsible for the revival of the art of wood engraving which he taught at the Central School from 1905. He also taught composition, book illustration, poster and advertisement design. His association with the Central School lasted for 35 years. Many of the Artistic Crafts Series of Handbooks were illustrated by Rooke. The influence of Noel Rooke can be seen in the work of dozens of students and they, like John Farleigh, passed on the skills learnt from him to the next generation.

John Farleigh, *Drummer*, wood engraving, 1934. 14.9 × 9.3 (5¾ × 3¾). Archive P.442